WASHING WINDOWS III

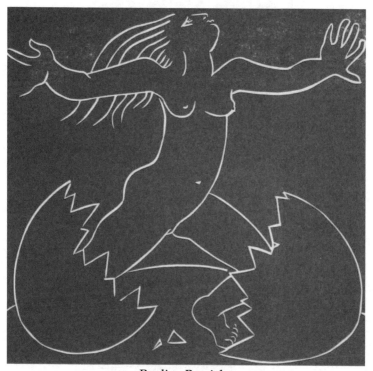

Pauline Bewick
WOMAN AWAKE
linocut • 21" x 16" • 1975

honouring

PAULINE BEWICK
(1935–2022)
Artist. Writer. Genius.

AILBHE SMYTH
Activist. Educator. Inspiration.

WASHING WINDOWS III

Irish Women Write Poetry

Alan Hayes and Nuala O'Connor

editors

ARLEN
HOUSE

WASHING WINDOWS III
Irish Women Write Poetry

is published in 2023 by
ARLEN HOUSE
42 Grange Abbey Road
Baldoyle
Dublin D13 A0F3, Ireland
arlenhouse@gmail.com
arlenhouse.ie

978–1–85132–321–0, *paperback*

Distributed internationally by
SYRACUSE UNIVERSITY PRESS
621 Skytop Road, Suite 110
Syracuse
New York
13244–5290
supress@syr.edu
syracuseuniversitypress.syr.edu

Typesetting by Arlen House

cover image: 'Reading and Thinking'
by Pauline Bewick
watercolour • 32" x 24" • 2000

LOTTERY FUNDED

CONTENTS

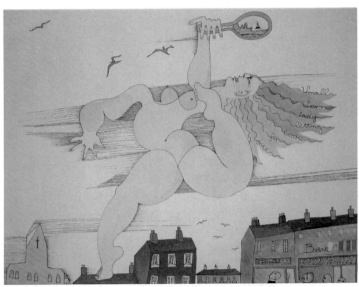

Pauline Bewick
SMALL TOWN LADY LETTING LOOSE
watercolour • 23" x 31" • 1973

Catherine Rose/Eavan Boland, 1980s

In 1984, Catherine Rose, Arlen House's publisher, and Eavan Boland, Arlen's associate editor, founded the national organisation for Irish women writers, Women's Education Bureau (WEB), to develop workshops, mentorship and supportive and safe creative spaces for women.

Eavan Boland travelled Ireland hosting workshops and mentoring emerging women writers. At one event a poet told Eavan she was reluctant to 'go public' with her creative work. She felt she couldn't tell her neighbours she was a poet – because they would think that she didn't wash her windows.

That is the space and the culture which Eavan Boland, Catherine Rose and their sister feminists subverted and exploded. The vast array of Irish women writers today, reaching international heights, owe a debt of gratitude to these trailblazers for their radical work revolutionising Irish writing and the literary scene. Now Irish writing is a more diverse and open space, for both women and men, because of the truly groundbreaking and perilous work started by visionaries like Eavan Boland and Catherine Rose. Let us never forget. Let us never write their work out of history.

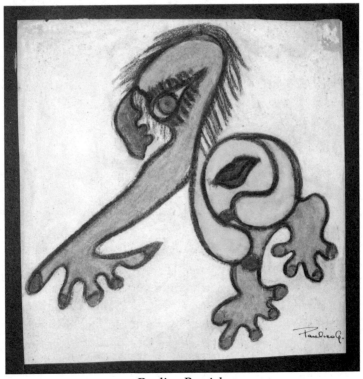

Pauline Bewick
ABORTION
pastel • 6" x 6" • 1948

Aged 13, living on a houseboat sailing the Kennet and Avon Canal, Pauline would listen to her mother, Harry, discussing philosophical and social issues with her friends. Following a conversation about reproductive rights, Pauline painted this as what she imagined abortion to be.

Poetry – Power, Politics, Patronage and Privilege

Alan Hayes

These 100 new poems which comprise *Washing Windows III* once again give us great hope for the future of Irish poetry. Selected from over 600 poems submitted by women who have yet to publish a full collection, I had challenging choices to make. So, while many poets didn't make it this time, it is heartening to know that the poetic talent out there by emerging female authors is immense.

Here are the voices who will shape a new poetry world. These writers come from all parts of the island and beyond. They range in age over seven decades, and, as with all Arlen House anthologies, diversity is integrated throughout, in all its glory and in all its honesty. There are strong familial and community ties here. Many of these women have contributed to Ireland's cultural life for decades as prose writers, playwrights and visual artists. All have an interest in poetry, often from the days when an interest was not encouraged or welcomed. Thus, this anthology is representative of a new society and a new way of accepting and honouring the talent all around us.

Though it has not always been so.

Women who are poets have not always been accepted or welcomed on equal terms. Talent has not always been the key factor. Power structures operate in dark corners.

There certainly have been better times for female poets in Ireland's literary history. The nineteenth century was, relatively, a golden time for Irish women writers. Anne Colman, in truly groundbreaking research in pre-internet days, discovered over 700 women writing poetry during the 1800s. In ongoing research, I have discovered over 100 Irish women who published poetry during the twentieth century who have not yet been 'reclaimed'. However, it is clear from the 1950s onwards that conservative powerbrokers chose to champion their male peers and, in most instances, female voices were silenced. I believe there were always female voices who could be silenced.

Galway, 1975: Arlen House – Ireland's pioneering first feminist press – was established by Catherine Rose, a young Cork woman. She gathered together a small group of other extraordinary women, including emerging poet Eavan Boland, who brought visionary ideas and practical help, and feminist activist and seer, Dr Margaret Mac Curtain, one of the leading voices campaigning for equality in society. I believe all women writing today owe a debt of gratitude to these trailblazers who were the first to open doors, at a time when it was difficult and dangerous to do so. They started a new creative movement, demanding a space, a voice and a vision for women. Thus commenced a new flowering, which we witness today as a renaissance of renowned female voices.

Though it may not always be so.

Unless systemic changes are made and enforced, progressive improvements in equality and diversity can always be dismantled. Power systems operate by twisted untruths. Recent ministers for arts have successfully delivered large increases in arts funding, thus many

projects centered on the current 'diversity' buzzword have rightfully been supported. But what will happen when budget cuts come again? Will the decision-makers revert back to prioritising the old power structures – which traditionally had a poor record of equality and diversity? Artistic organisations existed with specialisms in equality and diversity, but then had their funding either cut, or completely abolished, when funding bodies faced with budget cuts made poor choices. The Arts Council/An Chomhairle Ealaíon, in particular, needs to be monitored closely. While Arlen House has the longest track record in equality, I do not feel that the Arts Council is a safe space creatively or culturally.

This year I was delighted once again to invite Nuala O'Connor to co-edit *Washing Windows III*. In her vivid introduction she reflects on the power and importance of poetry and considers many of the fascinating themes emerging in this anthology. 2023 marks the 20th anniversary of Nuala's first collection. Arlen House was privileged to introduce one of the most original and important voices of twenty-first century literature. In 2003, the poetry world was vastly different to today. It was a space that was not as open and welcoming to women. I remember one young female poet saying she was told, patronisingly and condescendingly, that there was not one line of poetry in her manuscript – an opinion that awards judges, media reviewers and a large audience utterly disagreed with.

Diversity was not even a buzzword in the artistic lexicon then, despite the fact that equality legislation had recently been enacted by the government, and equality and diversity measures should have been implemented by all powerbrokers and decision-makers. It is inexplicable why it took so long, and disturbing when it is done so ineptly at times now. Often, Jessie Lendennie at Salmon

Poetry remained a lone beacon advocating for progress and change in the poetry world. And sometimes a price had to be paid for doing so. Powerful publishers in the western world continued their long-standing exclusionary practices, often with public support and the approval of funding bodies; in Ireland the output of poetry presses, generally, was not reflective of modern society.

But the growing body of women poets, many of whom emerged from Arlen House/Eavan Boland's pioneering WEB workshops in the 1980s, demanded opportunities; they refused to be silenced or sidelined. Thus came a new beginning for poetry in both the English and Irish languages. With the right supports, independent management, and honest engagement by the entire arts world, this is the perfect time to create opportunities for growth and blossoming.

Will that happen? Power structures remain stubbornly resistant to real change. We are told 'change takes time' – though nobody explains why that is so. And why do *we* allow it to be so? Over recent decades, the Irish poetry world has become increasingly younger, female and more diverse; a fact not represented adequately by powerbrokers and decision-makers. Tokenism is not acceptable.

This anthology honours Ailbhe Smyth and the late Pauline Bewick, in acknowledgement of their visionary, brave and extraordinary contributions to Irish life over many decades. Pauline's transformative art graces these pages.

For recommendations and wisdom, thanks to Donal Ryan, Maureen Boyle, Geraldine Mills, Nessa O'Mahony, Joseph Woods, Siobhán Hutson, Dairena Ní Chinnéide.

And for now, and for ever, let us raise our voices to celebrate these 100 new poets, help them on their journeys and watch as they bring new vitality into Irish and international creative life.

And let it always be so.

PINNING WISPS

Nuala O'Connor

Where do poems come from? Are they passing wisps we grab at and pin down, driven by an urgent desire to change their nebulous forms to something palpable? Or are poems already inside us, a miasma of opinion and memory, fact and fiction, gathering like a tornado to whirl out of us and onto the page? Most poets don't know how a poem gets into or out of them, they just know it happens, and that the expulsion of every poem is significant.

Finding and forming poetry is a sensuous act. A poem, no matter how it enters or leaves us, needs alert senses and a special sort of attendance. The poet tunes her ear, listens well, and studies, from many angles, the contours of the miasma that has come to – or lives inside – her. She feels the texture of the wisp she has apprehended, measures the coolness or heat of it, holds its weight in her hands. She examines what has arrived to her thoroughly, looks away, looks back at it. The poet dredges up memories, associations that have travelled with this formless thing – scraps loaded with meaning. She stops, listens again,

serves the feeling or idea that has brought the unformed, urgent fragment to her and, eventually, she begins.

The poets in *Washing Windows III* are suitably attentive; each poet here has taken the measure of her wisps. And she takes her obligations seriously: firstly, to herself and then, to the fragments she has caught. Her duty is to gift readers a new, tenderly made object – the poem – to see what they might make of it, and to gain understanding for herself.

I personally make much of the poems in this beautiful anthology. Síle Agnew's opening prose poem 'Meeting the Dead' is a stunner, with its affectionate poke at those gone before, and a laying out of the gorgeous specifics of their lives: 'My dead mother-in-law comes round the corner. "Just as well he took you off the shelf." And she disappears before I can respond.'

Death, the impact of loss, and grief feature prominently, as you might expect. Marie Breen-Smyth gives us a moving elegy for a lost partner in 'Emeralds', exploring the echoing finality of death and the loneliness felt in its aftermath:

I kissed the last of your warmth.
There is nothing now
where you were. Nothing at all

but an old wedding band
and emerald tears
on my right hand.

Another dazzling elegy comes in the form of Winifred McNulty's verses in memory of writer Leland Bardwell, full of lovely imagery and concrete things; she imagines the poet's missing voice to be the '... bright eye of the sea, pale/frost mirage, deep waves crashing far out, rip curls/for no one but themselves.'

In Sorcha de Brún's finely crafted and fresh 'Bás Nádúrtha', she wishes for another kind of death – a

natural one – for a relationship, saying 'Is fearr an scaoileadh ciúin ná éirí ar bhuacán na toinne feirge'/'Quiet release is better than rising on the crest of a wave of anger'.

The safety of children, both young and older – and worry for their futures – is brilliantly explored by several poets, including Ger Duffy, in her exquisitely detailed 'Somewhere Near Ulcinj'. In this poem, the specifics of a dangerous encounter are left for the reader to guess at, while the details of Montenegro, the place where it happened, are vividly recorded, including a visit to a police station:

> ... Something about our dirty shorts
>
> and torn tops angered them. We used their toilet
> with its stack of porn mags, greasy light, beauty calendar.
>
> We slept sitting upright outside until goat bells woke us.

The variety of subject matters is one of the best aspects of anthologies, and the poets here throw their nets wide to catch the truths, or obsessions, they want to explore. In a book by women, naturally, mothers are hugely present. Carol Farnan, in the elegantly constructed poem 'Fetch' finds her own mother in her reflection during the sequestered days of the pandemic:

> The mirror fetches you to me. You emerge from under my
> lockdown hair, newly-white, emphasising the blue of my
> eyes which – I now notice – are your eyes [...]
> I see my long-dead mother and the self that has been waiting
> under the hairdresser's art, behind these days of pause and
> stasis.

Anita Gracey shines a welcome torch on bias towards disabled/differently-abled people in her wonderful, upfront prose poem, 'You Wha?':

> Door staff stop me, thinking I've had one too many, that I
> can't handle my drink, but then I say *I'm not drunk, I've
> slurred speech.* They squint into my wobbly walk, my
> disappearing words, my explosive talk.

And Anita Greg writes charmingly matter-of-factly about a unicorn invasion and sees one at a wheely bin 'riffling through debris with his pearly feet', while his mate scratches 'her haunches on the Pay & Display machine', and both creatures stare at the narrator 'with their strange unworldly eyes'.

More familiar inhabitants of the natural appear in the form of starlings, gorgeously laid out by Martina Dalton in 'Murmuration at the Backstrand':

... In their beaks
they lift the earth. Pinch each corner tight
before the fold. Stretch a sheet as far
as human eye can comprehend – then shake it out.

Murmurations appear again, in Therese Kieran's stunning childbirth poem 'Belfast, 5 January 1994', where the new baby makes of the poet 'a mothering murmuration; one that forever circles, hovers, swerves, swoops, scoops or dashes away.'

It is wonderful to witness so many of these poets wrestle with the act of creating itself – the mechanics and the results, the joys and revelations inherent in writing. Frustration with the bookish world is also evident. Anne Marie Kennedy pokes fun at the literary establishment, its navel-gazing and overblown egos, in 'I'm Literally Two Timing', where she uses language as a measurement. She comes down on the side of authenticity and informal modes of expression over high-blown literary rhetoric: 'Oh they'd sniff out the self-titled scribe/within a square mile a Menla & middlin' lively put a halt to/the over-wordy gallop of a gee-bag, a blow bag or a *gabhlóg*.'

For her particular wisp-gathering, Helen Clements turns to the transformative nature of creativity, giving us a metaphor poem – after Terry Tempest Williams – on all that can be revealed in creative acts. Clements says:

With writing comes savagery. [...]

And, should it choose to root and delve,
prompts its maw to open wide – unlocking jaws
to emit a roar which can't be quelled,
surprising even the bear,
so used as it is to solitude; to being left alone.

Orla Martin examines the writer's never-ending push-pull between earning a living and trying to be an artist; the narrator works in a city bank, where her day is all clang and clash but, at night, she finds refuge and hope in creativity, stating:

blue walls protect me where I can
create
something beautiful,
perhaps.

Mitzie Murphy tackles writerly procrastination with wit, claiming she will sit down and write when, among other things, she has 'Power-hosed my heart/Juiced all the uneaten fruit/Checked on the baby/Fine-combed the guilt from my hair/Scraped all the dirt from the corners of my family.'

Some of the writers here play with form – it is heartening to this reader to see so many prose poems in this anthology, for example. But Raquel McKee, in 'My Granny', uses an arresting, cumulative, stair-step form to great effect in a poem honouring her grandmother's life and work and, ultimately, McKee's own skills and creative power:

My granny
My granny sings
My granny sings trauma
My granny sings trauma lullabies
My granny sings trauma lullabies working
My granny sings trauma lullabies working cane fields ...

Language is, of course, honoured by all these poets and is used to outstanding effect, often. Grace O'Doherty gets gorgeously colloquial in 'Visitors', where she has the older

female narrator say, of cleaning her house for guests: 'The oven door nearly killed me/But look – how our feet are thrown back to us/by the shine on the glass.'

Ciara Ní É is especially clever with language in her sharp, sensual 'An Teanga Mharbh Seo', grappling with translation and living-language issues by riffing with 'tongue' in its meaning as both language and body part:

Seo í
an teanga mharbh seo
ag doirteadh as do bhéal is tú i mo bhéalsa.

Here she is
this dead tongue
pouring from your mouth while you are in mine.

Ruth Quinlan also turns to language frustration in her witty poem 'Mid-Atlantic', a lament for Gen Z's register-switch to odd, American-coded speech patterns:

With this ironing out of inflection,
homogenization of tongues,
her children will speak in Globish:
perfectly pronounced, perfectly generic

The body, love, and relationships are tackled by many of the poets here. Dawning sexuality is poignantly – and humorously – explored in a pair of coming out poems by Sonya Mulligan and Ger Moane; and Rachel Handley raises gender identity questions in the succinct, enigmatic 'Woman Adjacent':

Woman-adjacent.
That makes sense, doesn't
it? A not quite that
shape. If I try her
on she fits me for
a day, then slithers
off like a weary
skin. But not a him,
either. Adjacent,
not perpendicular.

Sarah Padden tackles bodies of a different kind in 'Yad Vashem', recording a visit to the Holocaust Remembrance Centre in Jerusalem, in a poem bursting with startling images and visceral reminders:

... I'm jolted into a Grimm tale of children
in camps hidden in forests, stinking in freezing
coffin beds stacked with stranger's bodies.

Women and the family are honoured throughout this anthology which is a gift to see. Eilis Stanley gives us sibling-appreciation in her fabulous, detail-spangled 'Thicker than Water':

Did I ever tell you I love
your laugh and the way you jig up and down when
you stand like you're about to fall out of yourself.

In her poignant poem 'Kalpana', Saakshi Patel gracefully examines the sacrifices of one woman – representing many women – for the betterment of the next generation of girls:

Swirling neon blue liquid anticlockwise
then clockwise, she scrubs loo bowls and drains,
bins the fallen hair, sponges toothpaste stains,
mops sweat with her saree and thanks the skies
for her daughter who finished studying and did well
enough to buy new clothes for mother and self.

The poet at work – like the collage artist – is in the assemblage business: she gathers, chooses, and discards. She pastes her words and images one way, then changes her mind, excises some, and leave others. She is aiming for harmony, for truth, for profundity. For a well-shaped, pleasing word-hoard that will lead to the best picture she knows how to produce. She understands when to add a musical note – a sound that is pleasing and apt. The poet is, as Sharon Olds would have it, one of 'the community of birds, singing to each other' who sends out her poetic call for 'love of language itself, love of sound, love of singing

itself, and the love of other birds.' The poet does not want to overload either poem or reader; she is judicious, careful, exact – she knows when to say just enough, when to honour her reader by acknowledging their intelligence, their insight.

And we would do well, as readers, to come to poems with ears, eyes, heart, and mind open, but with our feet firmly planted. Our attention to the poem should be as generous as the poet's has been to her craft. We should know that the poem is a whole, finished thing but, that like many things, a poem has porous edges – there is more outside of it than in. Things are left unsaid, sections left unpainted, and the reader can infer, can hear or say, these unsaid words, can fill in these blank spaces. And from them, if we wish, we can pull meaning and succour and news.

To read the poems in *Washing Windows III* is to come to these poets' final pictures – they have made the words, the 'message', the musicality, and the imagery work in harmony. The poet has completed her work – pinned her wisps – it is time for the reader to do hers.

WASHING WINDOWS III

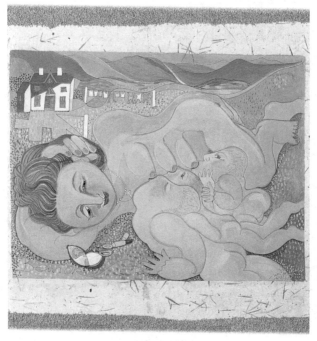

Pauline Bewick
MOTHER OF THREE
acrylic and grass seed • 24" x 32" • 1987/2000

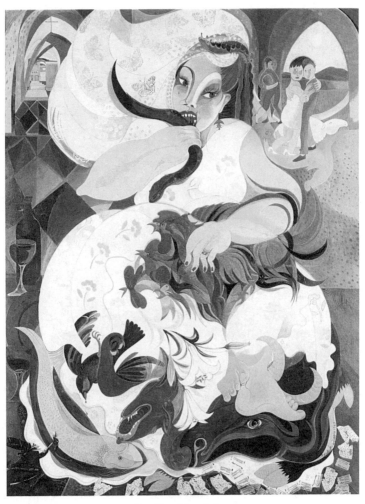

Pauline Bewick
THE GREEDY BRIDE
acrylic • 90" x 66" • 1989

Síle Agnew

MEETING THE DEAD

I bump into my dead father. He has rambled everywhere pooching. A wartime hoarder. Still hammering a hoop onto a barrel with precision, and him with only one good eye. Making flies to attract the buckin' fish he can never catch. He is 85. But I am not 45, I am vexed and old. I ask him 'How's it going, Bob?' He smiles at me, shakes his head, folds his arms across his chest and says 'I had a feed of pints with the lads, in Val's.'

I see my dead sister-in-law. She stamped lots of letters, weighed parcels and packages. She's smoking cigarette after cigarette. 'I thought you gave them up?' 'No,' she says. 'I still love them.'

I glimpse my dead mother. She has cycled miles around Kilcurry, walked through Faughart, and to the grotto in Inchicore to pray and eat the feet off the statues. Her nose is running water. She is 98. I am different. I'm odder, not who I was. 'How are ya, Mam?' She smiles and looks at me, into my eyes like she always did. 'I have been eating Battenburg cake in the Downshire Arms Hotel, singing dee ooh dee ay and Ramona on the way home in the car telling Robbie to mind the shuck, and if he doesn't I'll just have to say the rosary again.'

My dead mother-in-law comes round the corner. 'Just as well he took you off the shelf.' And she disappears before I can respond.

Marie Bashford-Synnott

IN THE WEIGH ROOM AN ANCIENT LADDER

In the Weigh Room an ancient ladder leads
upwards to a closed trapdoor.
Mended through the years, on each side
old holes left over from old nails,
new sections set in, new steps.

Generation after generation,
they clambered to the loft, son
following father, following grandfather.
Deep grooves in the wood marking
their passage: a monument.

People come to the Watermill,
restored, rebuilt now – wood, iron and stone.
The old ladder is a magnet – hands reach out
to touch, smooth the worn steps. Wonder.

Trish Bennett

THE GIFT

The day I lost you, I lay
cursed, covered in blood,

curled up in a heap
on flagstone tiles.

You left a gift
to help me heal.

I use it today.
Rough sparks ignite

as the self retreats,
releases the muse

to chisel into that place
where hearts break,

face pain,
again and again.

I would give back every vowel and verb,
adjective and metaphor,

for time and place,
love and loss.

I'd give back the awards, the grants,
the chances.

I'd lose every word
to keep you in this world

to smile in relief
at the sound of your first cry,

to smell that baby smell of you,
wipe those wet blonde curls

you'd have from your father's side.
I'd hold you skin-to-skin

as you opened your eyes
for the first time.

I'd give back this gift,
every damned letter of it.

to see you grow up
to be a gangly youth

chasing your father through fields
on scrambler bikes.

I'd stand to watch
without the words to express

how my heart
swells with pride.

Words
are all I have.

I tap at the keys
to ignite that spark you left,

chisel into that place,
that day,

that pain
on the grey flag of my heart.

Yvonne Boyle

CHILDLESS

'You're lucky you have no children'
people, mostly women, said to me
after my husband left.

'You're lucky you have no children'
women, mostly mothers, said to me.

I was forty-two then.
Now I'm sixty-two
I'm not so sure.

Caroline Bracken

DUBLIN CAN BE HEAVEN

Don't tell anyone
but I'm afraid for my daughter
when she walks around town
at 5pm
alone.

I wonder if
instead of a manicure
and a silver dog tag necklace
for Christmas I should gift her
a taser with enough voltage
to fell a six-foot man
chained to a five-stone
American Pitbull.
I fear I raised her too sweet.

Would she stop
if such a man and dog blocked her path?
Would she remove her AirPods
if a man dressed to kill
in a Hugo Boss suit asked directions
from O'Connell Street to Stephen's Green
even if
it was raining and she was tired
after a day's work?
Would she miss her bus to assist a stranger,
offer to walk part of the way with him
because this is her city
her hometown?
She knows every bridge
and alley and cobblestone.
What music might she be listening to
and would it play on?

Marie Breen-Smyth

EMERALDS
for Alan

Battle hardened by Belfast
the bomb in Bogota did not keep me
from jewellery streets of La Candelaria.

It was between a cushion cut
and two emerald teardrops.
I chose the tears.

The gold band fits me now.
My old wedding band
hangs on a chain round my neck.

There were bombs in London that day too.
Not that I noticed. Life blew apart
right under my nose.

I knew before the doctor's face.
Before your rictus smile.
Perfectly still. Still warm.

I kissed the last of your warmth.
There is nothing now
where you were. Nothing at all

but an old wedding band
and emerald tears
on my right hand.

Clodagh Brennan Harvey

CARING IN THE TIME OF COVID

Caring in the time of Covid
is an impossible thing.
Time bends and contracts
to fit any span –
an hour to brush my teeth
a week to plan the dinner
thirty seconds to repaper a room.

All things wait on my attendance,
nothing takes care of itself.
The stairs alone undulate at will
all those things I forgot to remember
half way up
or half way down.

Once a certain numbness sets in,
nomenclature fails too.
First, it's the names –
the names of things, the names of people;
syllables rebel and decamp,
their forms vaporising.

Distraction-hungry
we scarcely notice
the souls' migration,
taking advantage of any aperture.

We huddle now as bears do,
noses down on the tundra,
frozen,
primitive,
sustaining the loss.

Jacquie Burgess

NIGHT REVERIE

Lying awake in the dark night
my heart grows bright
as love flows through
the cracks of this world
balm to grief and desire
ease to uncertainty
and all those endless questions
the nature of a reality
undeniable
this heart's holy ground

June Caldwell

MALE-IDENTIFIED

My friend is annoyed I called her male-identified.
I was shite to her before she died.
Knew she was weak, up to no good.
Tortured her a bit for fun. Said things, flung wood.
I wanted her to admit some men are incredibly dangerous.

We shared a flat in our twenties.
Ever the raconteur she painted the place orange.
Soirées, late nights, we ate carrots to slim down.
Look your best to get the right ones,
the ones we deserved.

We go to a WhatsApp group to state the obvious.
Ribs break, bruises brighten. The politics of DARVO,
four cycles. And after, the makey-up bit, last phase,
oh dipsy honeymoon!
Seductive as fuck, trauma bonding.

You know how it goes with women.
Always riling, pushing, nagging, pulling ...
In the end, a fish ate her eye in the Australian jungle.
God love him, she said,
gurgling.

Lynn Caldwell

CAROLINE ZORN AND JEAN WHELER

My grandmothers
both homestead-strong
their houses built of logs, sod
elements of Saskatchewan
their hands in the soil
drink from their own wells
eat what the stony ground surrenders.

Carrie and Jean write lines of their own
in the dirt of Prince Albert, Neeb –
see farther than prairie-wide spaces
shake the dust from their clothes
for the blue mountains of BC.

They give me the far edge of that land
where the words in the wind
are written in trees
and white caps.
You can stand on the brink
see farther than east
stronger than west.

They gave me their names
and I follow the cardinal line
due east, fly straight
home on my rain-slick garden
looking out to a purple-leaf plum tree
where magpies nest
let lines of white sheets
and blue jeans gust.

Marion Clarke

SOMETHING IN THE AIR

first light ...
a seabird's cry carries
the promise of adventure

I jump out of bed, pull on my swimsuit and shorts.
Downstairs, my younger siblings are already chattering in
the kitchen. I gather the nets and buckets and take them
across the road to the beach. The wee ones squeal as they
splash each other with breath-stealing lough water. Down
at the rocks we catch green crabs and sunlight in our nets.
The morning ticks its way towards the heat of midday.

I spot a blond boy over by the beach wall, his hair tousled
in the wind. He is squinting at coloured yachts skimming
the bay. I am intrigued by this solitary newcomer, and
imagine him as some sort of 'lost boy.' When he smiles, I
smile back and find myself walking towards him. We
begin chatting. I discover he is staying with relatives in the
town. I know his cousins. For some reason this pleases me,
and I suggest he hang out with us while he's here. When
he frowns and tells me he is leaving later that day, I feel a
strange sense of panic. Then his smile reappears. 'But I'll
be back next summer.' When he suggests we become pen
pals, I nod. He produces a pen from his back pocket, takes
my left arm and gently writes his name and address along
the inner part. I will not wash it for a fortnight.

end of summer ...
the ice cream truck's tune
off-kilter

Martina Dalton

MURMURATION AT THE BACKSTRAND

Come fast around the racecourse; disappear
completely as they turn, then flash
all black and white and shimmer as they go.
Like a flyby on Remembrance Day, tip their wings
in unison. Salute the non-existent crowd below.

Then they are gone again beyond the spit. A flock
of foam sticking to its edge.
Two young guns stab the sky in chevrons
as they leave. And what is this thing they lift
and spread. This bed they're shaking out,

in squares above our heads. A pattern
we can recognise? To disappear. In their beaks
they lift the earth. Pinch each corner tight
before the fold. Stretch a sheet as far
as human eye can comprehend – then shake it out.

Flick of a magician's wrist
and they are gone again.
Wind fills the space they've left, in whispers
light as rumour. Sea shivers in delight.
Accepts what has been said, as gospel.

A sky this empty draws all life, up and beyond.
Each reed as if it's been dipped in ink.
That which had been full of flight, has thrown
a veil of mourning. The grasses lean
toward their leaving – pleading,

Please come back.

Maureen Daly

I AM MEANT TO HAVE VOICES

that shout or whisper in my head,
to attend a psychiatrist,
take pills coloured like Smarties,
have high blood pressure or low
cholesterol and be on statins,
some gobbledygook abnormality.

I need to dismount my camel now,
fly to the moon
on my mermaid tail.

Sorcha de Brún

BÁS NÁDÚRTHA

Ach go bhfaighe an grá seo eadrainn bás nádúrtha,
Gan ciall a bhaint as nóiméidí éaga agus dúnadh ceana;
Gan focail dheiridh á rá idir fhírinne agus leathfhírinne:
Nach fearr, a ghrá, scarúint i léinseach seo na dea-aimsire?
Is fearr an scaoileadh ciúin ná éirí ar bhuacán na toinne
 feirge.
Ná bac an dráma bréige a chuirfidh teora lena ndeachaigh
 roimhe:
An chéad lá, an chéad áit ar casadh sinn ar a chéile,
Nár cheart gur chun dearmaid a bheidh an stair sin
 imithe?

Déanfaidh focail méid ár laethanta a rianú is fad ár
 míonna;
Dúnmharfóir é an plé a loit an saol is a chruthaíonn
 críonna.
Súfaidh cur is cúiteamh an mhilseacht as an gcuimhne:
An é gur mhaith leat diamhracht bhuan an ghrá a
 adhlacadh?

Siúlfaimis tolláin an iarghrá i dteannta na sluaite eile
 éalaithe
Gan féachaint siar, óráidí aiféala, gan mhilleán ná focail
 bhaotha,
Scarfaimid nuair a bhuaileann thiar is thoir is le croitheadh
 cinn,
Go bhfágfar agam suaimhneas intinne, is rian do láimhe ar
 mo phian.

Mairéad Donnellan

SYSTOLE

In your absence
my bed was quiet as a feather,
nothing
but muted mechanics
of the heart,
thimblefuls being issued
in and out of chambers,
shunted down
to the lower floors
like clockwork,
a little click of springs,
the dim snap of valves open
and close in strokes
like those origami fortune tellers
we made at school,
our fingers and thumbs
moving each quarter to and fro,
compelled to keep on going,
keeping the rhythm,
yellow, red, blue, green,
counting down
to the centre,
opening a fold
to find the name of one
we might come to love.

Rosemary Donnelly

MEMORIES

Cows' milk kept
in a small cool outhouse
with meshed windows.
Fresh cream skimmed
from each enamelled white bucket.

The smell of soda farls and pancakes
baking on the griddle.
Farm workers talk and laugh,
drink buttermilk with their dinners.

Hot porridge comforts
on frosty mornings
before the walk to school.
Grimm's Fairy Tales
charm winter nights.

Today a sparrow flies
into the kitchen.
I catch it,
feel its heart
beating in my hand.

Doreen Duffy

THE WORD CARETAKER

It wasn't in the leaving
or the ticking of the clock
when it was time to go
that almost killed me,
but the effort of trying
to pack words into a sentence
that you could carry
across the many miles
that you would go.

I wanted words
that were weightless,
no excess baggage
for your trip,
gentle, soothing words
you could lay
your head against
to rest,

soft pillows of words
to wrap your arms around,
words to hold you tight,
keep you buoyant
in swollen waters
reflecting clouds
of cotton white

words to stretch over a sky
of sunset scarlet silk,
to brush against your skin
in blue evening breezes,
while over here I hold my breath.

Ger Duffy

SOMEWHERE NEAR ULCINJ

All day, black clad women shook their heads
when we asked for *Soba* or *Zimmer*. We trudged

the curve of that scooped out bay to every
whitewashed house as the landscape wobbled.

Men watched us behind hooded lids, young girls
fingered our hair, our clothes, until dusk swallowed

the last light. Violins sang with the waves, coloured
lights danced by the shore, glasses clattered in bars,

the smells of fish and garlic clung to our skin. We sat
on a low wall as the full face of a yellow moon rose.

Upside down fishing boats proved unsuitable for sleeping.
We reached the end of the beach accompanied by

stray cats, lapping waves. Dark trees sharp against
the night sky followed us uphill, until we arrived at

a clearing. Pia sat down, I stood – looked ahead,
then to each side, then behind where I saw two white

t-shirts, crouched low, staring back. Pia asked, *What is?*
RUN, I said *RUN*, we threw ourselves at darkness,

trees crashed and fell, the ground rose to cut our arms,
legs, the sky fell righted itself, fell again; we slipped

down that hill like two Jills. What might happen
to two Jills, happened to us. Next morning, we arrived

at the *Militia* where they viewed us under peaked caps
and muttered '*Bre, bre*'. Something about our dirty shorts

and torn tops angered them. We used their toilet
with its stack of porn mags, greasy light, beauty calendar.

We slept sitting upright outside until goat bells woke us.
Retracing our steps, we found our passports, tickets,

scattered underwear, seized each one as if they might
speak back to us. As the ancient bus arrived, we embraced

its arthritic doors, as if it was our mothers' womb come to
take us home. As that bus creaked along the steep coast road

I thought of my mother, of how we would go on being
pursued, our daughters, their daughters.

Micheline Egan

CRAIC

It was a Tuesday around noon when she phoned.
I was in Kitty's Hair Salon on the Mall.

There was a strangeness in her and she couldn't stop.
She talked over me, interrupted, gushed.

I had to leave with wet hair covered in setting lotion
and rollers slipping out. I counted out the rosaries

on my red raw knuckles and gouged my arms with sharp
nails on the Dublin train.

By the time I got to the flat there was a guard and doctor.
My first born insisted I stay in the kitchen.

They kept her in the bedroom and tried to talk her down.
An ambulance was called. Queer words were mentioned.

The hallway was packed with bags of shopping.
Everyone else was in charge. I was the mother

who was fed sweet tea. When the ambulance men
moved her out gently, covered in a big grey blanket,

my eldest wouldn't let me hold her.

Orla Egan

HARMED

You, my love,
have been seriously hurt,
scarred on your soul
and tracking up your arms.

I am consumed by rage
against those who hurt you,
a desire to protect
and help to heal.

But what am I to do,
my love,
when the one who hurt you
is you?

Helen Fallon

CROCODILE TEARS

Mother's crocodile handbag her sister
sent from the States was stuffed with gloves, glasses,
a nail file, matches, blue rosary beads,
prayer book spilling novena cards, smelling
of stale tobacco and floral cologne,
suede interior smudged with red lipstick.

Sundays she strode up the steep chapel steps,
strap slung over her shoulder. It perched on
the pew as she prayed, stood sentry by her
seat at the parish party as she sipped
scented tea from a delicate China
cup with painted pink roses.

The crocodile skin blistered then cracked.
The belly drooped, the strap grew slack, her back
began to stoop. The seams unravelled.
She drove a darning needle through the gaps.
The bronze catch broke the year she had the fall,
the shoulder strap snapped sometime after that.

I found the handbag, back clearing the house,
flung under a scarf and the green silk blouse
I'd bought. It was crammed with postcards I'd sent,
tiny white tablets she took, crystal beads
that sparkled like ice when wiped with a cloth,
and a rock solid pink powder blusher.

The customs officer asked if I had
anything to declare. I shook my head.
For how could I tell him how much of her
clung to that skin smelling of tobacco
and 4711 cologne.

Carole Farnan

FETCH

The mirror fetches you to me. You emerge from under my
lockdown hair, newly-white, emphasising the blue of my
eyes which – I now notice – are your eyes. The mirror has
become a time machine that takes me backwards and
forwards. I see my long-dead mother and the self that has
been waiting under the hairdresser's art, behind these days
of pause and stasis.

April snowfall
surprised bluebells
lapis etched on white

Both shock and comfort, seeing you in me, knowing you
were always waiting for me behind the mirror.

reaching out to me –
the pond pulling the sun
to kiss its face

Tanya Farrelly

BETTER

We'll meet, yes – of course we will.
But not tomorrow or the week after.
Because work is hectic, or the kids unwell
or if we're honest, we're too tired or too lazy.
And haven't we all the time in the world?
Until we hadn't.

My last memory of you is singing
in the Hibernia Bar to an unruly crowd.
And above the clamour of barroom chatter
you dedicated every song to your audience of one,
who left before the set's closure
because there'd always be another.

And I wonder what right have I to mourn
when others did so much better?
Maintained the meetups, the texts, the calls.
Failed to let time slip by like we did.
Waiting for a better hour, a better day.
But grief does not discriminate.

Viviana Fiorentino

CHILDHOOD

It's time to move. You place your old toys
in boxes, a Tetris game of wedging in teddies,
Legos, wooden trains with loads of tears and laughs,

books of nursery rhymes, a striped sock monster,
an origami frog, a red pen cap, a Barbie boot,
a mouse puppet you sewed with a plastic needle,

a sequin, rainbow flower buttons, green and blue
glass shards, twigs and sticks, papery lichens,
minute shells we once collected on a sandy beach.

Now you're turning twelve, no need to store
old passions, to gather dust in the new house,
better to seal and give them to charities.

Our body cells renew continuously,
if they could be opened, they would reveal
firmaments of proteins and enzymes

carrying silent chemical memories,
halos of past faces and voices binding
to amino acids in the smallest chamber of us.

Amy Gaffney

How Long is a Piece of String?

The dawning that this is not good news.
The days watching a drip and the nights hearing
the machines blip, blip. Blip into silence before
blip, blip, blipping once again.
The counting out pills, Monday Tuesday everyday.
The waiting. The waiting. The waiting. And hoping.
And wishing.
Trawling websites for answers. Asking, begging,
pleading, praying ... *why?*
The length of a last breath. Those three days before
the slow march behind the coffin.
The Rosaries unheard, the grass clods,
seen and ignored, stacked under a green baize.

The summer day when I thought I saw you.
But didn't. Did I?

The moment I knew it was over between us
and the gleaning of meaning in the opening of an email,
a text message. The scanning of a Viber, a WhatsApp.
Asking, begging, pleading, praying ... *why?*
Trawling websites for answers. Navigating
the seasickness of watching you
slowly dissolve from my life,
the morphing from us to you
and someone else
under my own roof.
All before my own eyes.
Always these days.
The summer day when I thought
I saw you. But didn't. Did I?
It never switches off.
I don't know how long sadness is.

Shauna Gilligan

SOME THING

My mother was in her seventies or eighties;
at that age, it's hard to tell, people say.
She shuffled in my dead father's plaid slippers,
saying she used to be dainty and now
she was just numb, but nobody
really listened to her stories any more.

Not me, her fine son, busy drinking.

They were tired, the black and tans
– you would think –
of finding houses abandoned.
No pretty girls for them this night.
They found a woman, old, of indeterminate age;
They would make do.

In the pub, I was the storyteller.

My mother watched them, down there.
Doing. Some. Thing. To her.
First one soldier, then the other.
She pressed her nails into the flesh of her index finger,
trying to feel something, but she was still numb.

She didn't know the screams were hers.

I found her, dying, staring
at the line on her finger, neat
like a slice of evenly cut brown bread,
her thumb worrying the loose wedding ring on her finger.
What happened? she asked,
her eyes trying to focus on mine.

She didn't feel they'd missed her heart by an inch.

I stared at her legs: lumps of bleeding meat,
felt the slowing pulse in her wrist,
and I wanted to know what imprint
of my mother those men carried onwards,
their fingers still marked from the trigger
that aimed at one knee then the other.

Yes I, her fine son, will go now and fight.

Anita Gracey

YOU WHA?

Door staff stop me, thinking I've had one too many, that I can't handle my drink, but then I say *I'm not drunk, I've slurred speech.* They squint into my wobbly walk, my disappearing words, my explosive talk. Before swinging open the doors to a magical land of Tia Maria, where sweat and a perfume of noise beckons me in. A promise of being accepted.

I can feel your judgement – waiter, retail operator. I see the glaze in your eyes, the quizzical brow, the backward step, but burn those medical books, I'm not for diagnosing. I remember once a street person lurched over saying "it's a pity for her" to my Mum. He waved his beer can and laughingly said I "walked like a drunk". Mum didn't say anything but put her head down and kept walking. My hackles raised, skin thickened.

Easy to put a label on me. 'One of Them'. What? A protestant/ catholic/ Irish/ British/ republican/ loyalist/ gay? So many labels; the label 'disability' my trump card. A disabled woman. I'm here to break the myths. *I'm not drunk, I've slurred speech.* I've a lot to say. If it takes a bit longer, that's ok with me.

I'm a woman. I delight with my eyes, I emphasise with my hands. There's a satisfaction in lips, it's in the wink of teeth, the curl of tongue. We'll get past *I'm not drunk, I've slurred speech.* We'll find a common area. I'm me.

Angela Graham

MY BEDROOM WINDOW, REID STREET,
EAST BELFAST, 1964 (AGED 7)

In all my years of looking from that room
I never saw another face look back
from the terrace that ran back-to-back with ours.
No sign of life: the backyard walls so high,
so narrow the back lane that no one could be seen,
and many of the yards were half-roofed in. Just once
I glimpsed a human being, from the back.

He worked nights, cleaning buses, a recluse,
my Mammy said. That's why we never saw him,
the man next door, but we could hear him, hammering.
A chunk broke loose from my bedroom wall and hung
like a lump of flesh hangs from a wound by a strip
of skin that tears a little more each day.
The raw brick was a sore eye, staring.

I thought of the buses waiting for him in their shed –
cattle, cantankerous, itching for the rubdown and the hose.
Did they talk to him as he swept their corrugated floors?
Did he get to know their quirks and preferences?
Did he glean how their day had been, these beasts of burden?
Did he leave them gleaming, and empty, and coming back
to their grime, was he glad to have escaped the human herd?

When I saw the hammerer (black-haired, colourless),
hanging by a strap across his back was a canvas bag.
He opened his backyard door, went out, vanished.
I told a friend about him. Her eyes were wide.
I told her more – he planned to kill my Mammy.
She nodded. I realised I'd never get it back.
My first artistic sin. My third Confession.

Mim Greene

BAKED
for Duane & Catherine

The tins that we were baked in
have been handed down from grandmother to mother,
to daughter, for a thousand years.

The dints and damage forming the very shape of our
limbs. Pushing down beliefs and trauma that we believe
are ours because of our sins.
Suspicion has become truth,
fear our guard.

There's a whiff of some panic in me every time I see food
go down the drain.
Perhaps I can save it, dry it out for the birds?
Something happened so long ago that it cannot be
remembered ...
but it's still here,
in me, in my sister too.

It gets shoved forward until one brave soul
turns and takes it,
opens the box and lovingly holds the mistaken belief.

Love me back to life,
free me from my sin.
Remind me of my innocence,
let me be free again.

And so I turn.

Anita Greg

UNICORNS
I never thought there'd be such talk of unicorns

In two oh nineteen, all the talk
has been of unicorns – they have been spotted
in car parks, alleys, rummaging through bins.
It is the snow that's brought them into town
from their high places where the clouds
cross over with the tops of mountains
and all is white and nothingness.
 Or is it lack of snow that brought them down?
I'm not too sure.
We saw one yesterday, as large as life
scratching her haunches on the Pay & Display machine.
Her mate was in the corner, prising open wheelie bins
and riffling through debris with his pearly feet.

They seemed surprised to see us there.
Then stared right at us – unafraid
and fixed us with their strange unworldly eyes.

Sinéad Griffin

BREASTCHECK

At *Our Lady Queen of Peace,*
the chapel floats with *blue* inside.
I'm between sea and sky,
thinking of heaven.
I suppose I am meant to.
Except, the wall behind the crucifix,
is painted red,
stained to remind us we are the bloody
limitations of our bodies.

Kneeling, I call up the nuns'
litanies from our schooldays,
to thee we cry,
to thee we send up our sighs.
It's been a while.
But now because of all that's gone,
I think to visit,
each prayer one more small guilt,
my sister's lump was malignant.

X-ray shapes sail the screen.
I face mounds of tissue,
flashback to the old landing,
my sister, the unashamed naturalist,
the headlamps of her breasts come at me,
two rosy-flamed votives,
slow burning trouble.

Sharon Guard

SHOPPING LIST

You come to me with a shopping list
of specifications and requirements,
to see if I have what you are missing in

stock. You survey my shelves in hope,
quickly identify several store
cupboard staples, tick them in red.

The fancier items on your list are
interrogated for absolute relevance,
some are dismissed. Some you can live

without. They are icing – not cake.
Cake items – the eggs and butter and
flour and sugar – they all fulfil needs,

needs you maybe haven't realised
yet, buried stuff; the gossamer of ambition
so fine it's significance seeps slowly.

I appear to have most of what you require.
Some of the brand names are different,
some products acceptable substitutes.

The rim of your lip curls in relief. And now
I look through your shelves. We both know
one hundred percent matches are unlikely.

After all, we've been shopping before.
We have cupboards full of might needs,
aspirations and long expired dreams.

Christine Hammond

MENOPAUSE

Over 50, but I don't throw you out
my last box of tampons
hidden in a hot press womb
breathing quietly there
sighing a sanitary white lie
you still await your bloody employ
to stab the childless.

Rachel Handley

WOMAN-ADJACENT

Woman-adjacent.
That makes sense, doesn't
it? A not quite that
shape. If I try her
on she fits me for
a day, then slithers
off like a weary
skin. But not a him,
either. Adjacent,
not perpendicular.
Everything between
one shape. Another
shouting heartache when
someone else is placed
over me, when an
imposter breaks bones
to tell me who I
am.

Phyl Herbert

My cousin Penny sits at the breakfast table eating
her measured portions of kiwi and pear.
Her partner, Camille, opposite her.
'I used to have such a beautiful neck.
Men swooned over me. The fools.'
She holds her cup in mid-air, baptising her statement.
I was their guest for a few days.

Breakfast conversations with Penny and Camille meander
on every morning, often colliding with lunch. A sparrow
landing on a tree in their courtyard might give rise to a
lengthy discussion on the migration patterns of birds.
Me, I listened and observed how between them they
parsed the subject matter until it was squeezed dry.

I knew that fact about men swooning over Penny to be true.
Nearly forty years later, I still hadn't forgiven her.

'Remember that party in your flat in Dublin?'
She held my gaze.
'You left with my boyfriend draped around your neck.'
'He taught me how to be a good lover.'

I wanted to know what he taught her. I had to ask.
'Simple,' she murmured. 'Theory and practice.
Theory informs practice and practice corrects theory.'
I had practice in neither.
But Penny knew both sides of the coin.

Florence Heyhoe

INNER CHILD

No one listened back then. My voice silenced. They took
what they wanted. The secrets safe until the telling. In my
fifties, I held her while she wept and trembled, unravelling
together.

I found photographs of most of them, the ones I could
name. I sewed them all together with my machine. In and
out, over and over, the piercing felt good. My wounds
turning to wings.

striking a match
a wire basket
of memories

Mother never knew.

Jennifer Horgan

TO SAFETY

A column of dark green paint
takes on the shape of our son's body.
Like he's standing straight and still
at the end of our bed, waiting.
We walked to remember
my cousin's dead boy today.
His room unchanged,
the bedroom light left on
while we walked with his friends.
Growing beards now, getting taller.
There is something here in the dark.
Something pecking at
the softness of your body.
I wish it would leave.
That I might sleep.
Your snoring is loud.
I close my eyes, travel
down – there is a thin door
opening, banging shut in a house
of wood with a wraparound porch.
That's the sound. Wind.
The banging of a door.
It's not mid-November.
Not anymore. Not two years since.
It's hot. Dry. Summer. There are wings in the gauze
of the door still buzzing. I turn and see myself in a chair.
An old man. I am an old man sleeping.
A mustard-coloured newspaper
on my chest. Rising. Falling.
And there is nobody left.
Nobody left in the whole world
to see it.

Deirdre Hyland

MINNIE CRILLEY CLARKE
after Margaret Clarke's 'Robin Redbreast'

You know your place, sister.
Magisterial in your stance and gaze.
No Rosaleen
but a Brehon lawyer dressed in vermillion
as theatrical as the Abbey stage.

A suffragette of Inisheer,
no hell,
but a republic of shawlies and artists
learning idioms, patterns, potions,
mixing lapis, stirring madder,
concocting a renaissance.

The fleur de lys fades on the virgin blue.
Your long fingers glow gold and sapphire.
Bright braid encircles your serious face.
A Brigid for this place.

Jean James

Here are the five-toed men,
grey-backed, black-faced,
moving up as dusk settles.
Short-legged, wide-bodied,
good mining stock.

They grunt through mud,
stumbling in rot and stink
along the trenches,
blind until the yellow stars
of flares illuminate their sett.

These are the excavators,
blessed with spade paws
to scrabble out the earth
and proffer shelter
for others of their clan.

But some lie sacrificed,
pale underbellies squirming,
rich with rats,
a warning to the world
of how war culls.

Rosemary Jenkinson

AXIS MUNDI

It's the tiny things that matter on our trip to Armagh,
the way you tug on my arm when I cross a busy road,
the way you lace up my walking boots tight,
the way you warm my hands in the hyperborean wind
but our minds don't meet and match,
and back in the hotel here's the catch –
while I talk of the future, riven with striving,
you tell me you only live for the now.

Why does every time with you
feel like the first and the last?
The thirst and the gasp, the burst and the clasp.
In the graveyard we can't even find the past,
whispering 'sorry' when we step on the graves,
our boots slipping in the mud and the clay.

On our final morning at Navan Fort
the air is dizzy with the buzzard's call
and when we climb up to the mesocosm,
heaven and earth collide, past and present,
till we are suddenly blown off our axis,
the tines of light shining down on us
and all is limpidly clear why we're here and
why the world has sewn us together.

Anne Marie Kennedy

I'M LITERALLY TWO TIMING

I'm sick to the teeth of the poetry readings, the literary
lunches, the book launches. I'm tired of loitering in the
lukewarm draughts of long-winded curators who poeticize
the privileges of the writing life with their palavers &
plaudits (being particularly empathetic for pathetic poetry),
paralysing me with their proselytising diatribe on the
vagaries of self-exploration, extrapolating & navel gazing,
always stating Beckett the great absurdist for the sage-st
advice; to keep failing & to keep failing better – tell that to
your plumber, electrician or progressive dairy farmer. Yes,
my friends, that's the typical bill-of-fare at the so–called
literary gathering where no one has ever been barred from,
nor staggered out the door from because there's never
enough drink & too much thinking, about the self, the style,
the genre, the writer-ly voice, the plot devices. You'll have
the chattering classes from 'ort' clubs & societies, critical
analysts, be-cardiganed scholars & shameless self-believers
relieving themselves for hours with introspective musings
on the muse & her foibles, highbrow rhetoric flung down
from decorated pulpits, places you'd never be seen wheeled,
buckled, steamed or scuttered at, places that make me ache
for my place of birth in north Galway & Skehana's earthly
vernacular, where they mangle the language beautifully,
musically, to suit landscape, situation & oration. Ya could
ruin yourself beyant in Ruane's in Glentane spoutin' about
the haiku in yer auld high falutin' accent where they don't
give a rat's arse about hyphen or hyperbole 'a gobshite'
they'd call ya with yer shitehawking, shite-talk about the
split infinitive. The split infinitive! They'd split yer forehead
first with a belt of a crowbar, or a tap of a lump hammer. As
for the metaphor, musha, couldn't you just say what you
mean & mean what you say like, they'd laugh out loud at
yer lyricism, '*éist anois*' they'd say 'listen to this *loodramán*

with his oxymoronic this & paradoxically speaking that pure bolloxoloy that's what that is, in Bawnogues & keep yer auld classical allusions to yerself, we've no class a use for them around here as for the aphorism – 'tis far from the aphorism you were reared below at the brow of Esker bog, where there was no blank verse nor free verse & was there any verse at all, in your ancestry.' Oh they'd sniff out the self-titled scribe within a square mile a Menla & middlin' lively put a halt to the over-wordy gallop of a gee-bag, a blow bag or a *gabhlóg*. They'd put a stick in the spokes of a spoken word poet, shove two stubby middle fingers up at the cock-of-the-walk, the loud mouth or big talker. Don't be talking to them about the pulse of your prose or the confluence of your fluency, they'd pulverise your preferred pronouns into beet pulp in Pullnabrone, call a man a sleeveen for lot less in Screen's in Guilka where, disregarding gender, they'd render HIM a cute hoor or a hoor's ghost 'don't be humbuggin' us with yer hypothesis, see that door' they'd say 'tis out the *geata* with ya, ya latchiko, with yer auld book talk, the cut a ya, the gimp a ya get up to fuck from a-then forninth the fire & shove yer assonance up your arse, up high where the light doesn't shine & shove yer arrogance up after it' & hence, ladies & gents, the genesis for my *scéal*, a quare poetic conceit, a confession of the private dichotomy that's got me bestriding two fences, my roots entangled in rural language, my branches often dip into literary assemblages where criterion is met with academic success or publishing status, my preference is yet for the place & poetry of the peasant, the ordinary dacent man & woman, the farmer, the welder, the plasterer, the homemaker, the love makers, fishermen & troublemakers, the special ones, those materially poor yet gracious, the wise illiterate, the swaggery blaggard. It falls to me to bring them in from the margins, from grass verge to headland & halting site & put them down on my page & up on a stage to celebrate my first known world with respect for their ways & vitally, in their own words.

Wilma Kenny

FIVE DAYS OF WINTER

1

The old ash tree is exposed. Autumn leaves dropped.
In winter our souls shed the dross; we sleep it off.
We wait for new growth when the nights turn.
Only the rose hips remain.

2

Today I ache to be where the olive trees grow;
the *abetos* reach the sky as tall as the spire
of La Catedral de Santa Maria de Girona.
Do the bells chime in my absence?

3

One winter's night my mother sneaked away.
I wasn't watching. Trembling I ran from her deathbed;
the hurricane blows again. There is something in me
needs to stay on God's damaged earth.

4

In early winter we salvaged the last of the apples
growing on the little tree in the garden.
We made crumble sweet with sugar syrup;
it oozed down the side of the old enamel tin.

5

Navy sky; short day; long night.
We sit it out and know the time will pass.
I smell the rain. Embrace the silence.
Like the trees we look out for each other.

Elaine Kiely

BOY

Sometimes, when you are sleeping
I like to place my face close to yours,
as near as I can without touching you.

Still, I wait for your outward breath,
inhale the warmth that so recently lay within you.
Your skin is plump, but not as plump as it once was.

This past year has stretched you.
Your forehead is clammy and hair damp.
I smell drool and boyhood and biscuits.

A small light casts a peach half-moon
around us. This late moment
is ours alone.

My breath catches and I suppress
the dread. This is now
and this is sweet.

Therese Kieran

On the eve of Nollaig na mBan the sofa is my kingdom and
I am extra, and munching Golden Wonder while my love
wrestles our first tumble dryer into the cupboard under
the stairs. It is after my last Christmas as a just-me woman
in spite of my married status; a woman labelled divil-may-
care, a woman without dependents, a woman free to come
and go, a woman with no need for weekend alarms. A
soaps woman, a cinema woman, an afternoon snooze
woman, an artsy-fartsy woman, a one-woman-show
woman. It is before I am registered mother, before I
answer to mum, before I feel a weight in my arms that's
heaviest still when they are empty. It is before hormonal
roulette and a rollercoaster of ups and downs; and the day
it all began was Nollaig na mBan, the feast of the
Epiphany, and allegedly a day when women in Ireland
take the day off, so they say. In the early hours of Nollaig
na mBan we lie in bed and sleep makes love to my love,
yet shuns me, so I wobble about, light-headed as a bee and
sugar plum. My rotund belly is drum-tight yet shape-
shifting while I long to lie face down. This I do in the
unclaimed back room, toes trailing the floor, eyes closing
until whoosh – a gush, a gravitational flush and we are
rushing, back and forth, down the stairs, into the hall, out
through the glass-fronted door into a frost-freckled night.
Out, out to greet the sparkling dark, to deserted streets, to
mist softening a streetlight's glare. Out to the last night of
twinkling lights on dying Christmas trees. Out to sleepy
houses and a police car siren blaring in the distance. Out to
road closures and security barricades, out to detours and
diversions until finally in. In to the laidback night
watchman, to his polished non-plussed at my puffing and
panting. Oh the fuss, the glorious fuss is all ours. On

Nollaig na mBan we are tricked by the deceit of a moodlit room and ice cubes rubbed on my belly, water on my lips, cannula, drip, catheter, monitor, beep beep, doze, sleep, sip, check. The sound of my baby's heartbeat is like wind racing through trees, but he arrives like a shooting star that breaks and remakes me a mothering murmuration; one that forever circles, hovers, swerves, swoops, scoops or dashes away.

Susan Knight

The joker that fell into your bag
three days ago
keeps falling out,
his grinning face and sharp eyes
enticing you to his world.

Drawn to the palaces by sleepless nights,
by flickering candlelight,
retracing loud footsteps along those marbled rooms.
Musty with dust in the hems of old suits,
the livery of the Borromeos,
worn by wax dummies with faint smiles
– what do they know but won't say?
Glimmering over the grime
on the skin of the stony child,
white as death,
clutching a skull, balancing an hour glass,
the sands half gone.

Pale light trembling on the rows of dolls
simulating movement
– or did they really blink and shudder
when they thought you weren't looking?
The puppets in the grotto are cruder,
less fearsome than those porcelain faces
with their empty eyes and spiteful mouths.

Give us Pulchinello, Arlecchino,
even the fire-breathing monster
before these beauties.
Even the devil or death.
Even the joker.

Róisín Leggett Bohan

THE FLAT ON KEIZERSGRACHT, AMSTERDAM

In this city of canals and elm seed confetti
I find a space of dust and dog hair tumbleweed.
A tall window allows a spill of light from the east
that splashes a stainless steel vase.
Best of all – a ladder to a loft.
Outside, a nest of swallows, sheltered under eaves.
I imagine the chicks emerging,
becoming the Morse code of my mornings.
There is a hook that hangs outside
where we pull up a walnut leather sofa
from the courtyard below.
A neighbour, who looks like Willem Dafoe,
navigates its journey.
A fan bats off mosquitoes, who still put up a fight.
Already, offerings dot my ankles.
A box of books stacked up against the thick white walls.
There is something in everything when you have nothing.
I stroke the table – it stretches and releases like a tree
flexing its gnarled knots.
Across it, a jar of crimson-tipped paint brushes,
colouring water. Crêpe paper in yellow and red wrapped
around a handmade soap of mint,
tied with hessian string, the scent permeates packaging.
A wooden crate in a corner
with a crayon scrawl of a white wolf,
his head bent lapping water.
I climb through the bay window
and settle on the roof slates
to remember myself here
with a koffie verkeerd and a book.
Freedom pealing from the bells of the Westerkerk.

Jackie Lynam

JUST SALT

It's a Saturday in February
and I hesitate before I criss-cross the city.
Essential Travel Only. Stay Home. Stay Safe.
But she's eighty and alone
and this is probably her last decade,
maybe even her final year.
And I am yearning to see her.

Just salt, she says,
when I ring to double check her order.
They don't open until five and it's cash only
but Macari's chips are worth the wait,
and the three euro coins fished
from handbags and coat pockets.

Her muffled voice behind the burgundy door:
Hang on, I'm coming.
It swings back, my eyes immediately drawn
to the paper mask pressed against her skin,
her face lit up beneath the covering.

Are you staying? Will you have some chips with me?
I hesitate again.
I better not. I'll take a few and eat them in the car.
She points to the black bag she lent me earlier:
Keep it in case you're stuck. Fold it back up
and leave it in your handbag, she instructs.
Don't forget about it!

Some day I'll stumble across that carrier
and I'll shed salty tears onto its plastic lining,
and curse the wasted year when I couldn't share chips
with my Mam, my dear.

Noelle Lynskey

CONFESSION TO MY FATHER

The day we buried you, I was discovered
there in your shed, among your stacks of turf
timber, old tea chests full of tools, spare
valves, bulbs and plugs and other daddy stuff.

Why my mother came out to the backyard
I'll never know. Our house, bewildered
with ham eaters, pot scrubbers, bread slicers,
whiskey drinkers, familiar voices and faces
I barely knew. Maybe she was escaping too,
running away from the sympathy, the pity,
the crushing handshakes.

Those slender gift boxes of Silk Cut and Carroll's
lying among the sliced loaves and borrowed glasses
were just too tempting for the nine-year-old me.
Armed with matches, my ten-year-old neighbour
and a fistful of cigarettes, there
in your shed we choked ourselves on smoke.

I don't remember
the airiness in my head,
our lungs drowning in the fumes.
 the guilty stifled giggles,
 and suppressed cough.
 But I do hear
my mother's voice, standing in those new shoes
that were killing her. There in her black dress,
eyes on fire.
 That's all I need.

Colette McAndrew

PHOTOGRAPHS

Pouring over glossy and faded prints
Homes long gone or remade in a new image
Observed over time and distance
Toys now redundant
Obsessions which passed
Gathered in an old shoe box
Recorded forever
A moment, a blink, a shutter closes
Postcards from the past that made the future
Happiness fleeting
Sad husks remaining

Catherine McCabe

FANAD DRIVE, CREGGAN, APRIL 2019

Knobbly knees and skinny laps of lanky adolescents
crouching behind the peace line
cradle rocks to be flung at anyone
while overhead a kid is crowned a gunman
in the masking of his face for a cause.

He surveys the crowd
surging, surging,
readies the gun, and for a second is solitary,
aiming at anyone under that grey sky.

And another lifeless body is stacked atop
this troubled history
where anyone
is always someone
else who didn't deserve to die.

Politicians hasten to the scene
to make war out of peace
in polished vernacular
from behind the demarcated line.

There's no DNA on the rocks
that scatter the ground
in the aftermath of this riot.
Still, everyone has porous formation,
expanding and changing,
always.

*This poem describes events preceding the death of Northern Irish journalist
Lyra McKee who was shot by a lone gunman who fired indiscriminately into
a rioting crowd. The title of the poem is the location and date of her death.*

Felicia McCarthy

MARILYN AND THE BOYS
for Jack

I didn't die that time, Mr President.
I left the building with Elvis.
At 2am he drove up in that pink
fin-tailed Cadillac of his, just as
I was about to sink into the valley
of the dolls. MAR-*lin,* he said, calling
my name in that Memphis boy drawl of his,
Y'all can't let 'em win the game.

We left for Vegas lickety-split, drove 'cross
the sands to the land of plenty good 'nough.
He wears my sequins and I wear his, we
make a living as look-alikes. You know,
that last life was fine with you, Bob and Jimmy
but this is better where all I gotta do is throw
the dice to decide who I wanna be that day.
The pay is steady, and we're jess like 'em.
Yer real good, they say.

Mary McCarthy

MAGIC TOUCH

A good day is a day above the ground,
when the web of magic flows
from small acts of kindness
least expected.
It's a path to the sky
taken by chance to Mars
in a time
where like flicking an electric switch,
it makes you come alive
to what it is.
The power of the landscape
seeps into your energy,
confident from being uplifted,
you are like the full moon visible shining brightly.

Deirdre McClay

WATCHING SURFERS AT ROSSNOWLAGH

Coddled in a warm room
I listen to the hum of blown air
pitch perfect to Atlantic thrum.
Below, walkers endure winds
and a foreshore debris-ed with rounds of foam
yields to the glassy film of ocean.

Sandpipers feast in the between lands;
they spill about on busy legs
evading a salty drowning.
While I watch a spattering of surfers –
flecks in rubbery stitched suits
striding with boards to the shallows.

In junior waves, surfers float, paddle and stand,
each to their own in water traffic,
while beyond a few wobble crests to shore.
Watching until they disappear, in grey and foam,
I wonder how they take to their ducking,
as I cannot follow their story.

Further out, the water is calm.
Surfers straddling boards
await the sassiest wave ashore.
And I wonder what happens when the swell comes.
Will they waltz as sandpipers?
Or jostle like seagulls over a fish surprised from the ocean?

Helen McClements

WRITING WITH THE BEARS
after Terry Tempest Williams

With writing comes savagery.
That's just how it is.
What may begin as gentle, lyrical prose,
ambling on the green, may, when it encounters thorny
thickets, growl slowly, showing teeth.

If poked, it may snarl and unfurl its claws.
And, should it choose to root and delve,
prompts its maw to open wide – unlocking jaws
to emit a roar which can't be quelled,
surprising even the bear,
so used as it is to solitude; to being left alone.

Come. Let your words unspool before they draw blood.
Find your inner bear with me.
Unleash that roar.

Hannagh McGinley

BUFFERMANSPLAINING

I often recall a time
when a white privileged
buffermansplained to me,
and all the other minorities,
with an almost scolding certainty
that racism was a serious issue.
He is the boss now.
Pass him the tissues.

Ellie Rose McKee

DISJOINTED

I am scared of my body.
My bones feel weak and
out of
 place.

I'm scared of joints
slipping;
cartridge ripping.
The hairs are loose in my head.

I creak, and crack.
Aches in my back
wake me up in the mid-
dle of dreams.

Fluctuating between up and down,
I worry more about getting
stuck on the downwards turn
than ever bouncing back between moods.

When I run, I hurt.
If I rush, I fall.
Edges of doors
pit dents in my skin.

I used to be scared of my gender,
sexuality and flaws –
the inner me.
But those things, at least, now seem safe.

For all the bumps and scrapes,
I barely bruise at all.

Raquel McKee

My Granny

My granny
My granny sings
My granny sings trauma
My granny sings trauma lullabies
My granny sings trauma lullabies working
My granny sings trauma lullabies working cane fields
My granny sings trauma lullabies working cane fields
 hopefully.

My granny sings *me* trauma lullabies working cane fields
 hopefully.

Me?
I sing Granny.

E.V. McLoughlin

OCTOBER IN THE RAILROAD BELFAST
(sort of) after Jack Kerouac

I tell you that, in my opinion, out of all the thin spaces
October is probably the thinnest,

the inflection point, a hinge of the seasons,
when old places are full of ghosts and the new ones
have no meaning *yet*. Or still.

They say it is impossible to enter the same river twice.
What they don't tell you is how inviting the black water is,
and how you see it always out of the corner of your eye.

How day after day you wake up and find
your shoes waterlogged and your pockets full of stones
and broken glass.

Leaves and darkness fall quicker and harder now,
like tears, old tickets and, more often than you think,
people.

Another train is delayed, so we wait
in the cold under orange lights,
and don't talk about what we already know.

Tell me, when a bird flits from branch to branch
and finds no purchase, for how long is it kind
to urge 'keep going'?

Tell me, how can you bear it?
And you say,
Like everything else. One day at a time.

Triona McMorrow

A BARGAIN

I bought a box of detergent,
sixty washes it said. At my age
that provokes thoughts of mortality.
So, I wash more than I should,
not wanting to be found dead
with unwashed underwear
in my laundry basket, neither
do I want to waste the powder.
It's all about balance.

Winifred Mc Nulty

IF YOUR VOICE CAME OUT OF AIR TODAY
i.m. Leland Bardwell

it would be Amazonite, bright eye of the sea, pale
frost mirage, deep waves crashing far out, rip curls
for no one but themselves.

They are speaking of you in Davis's, about a key
in an envelope to your blue door at the edge
open to storm and salt.

Once I put the fossil poem in your palm,
you cracked it open to let warmth in.

Josepha Madigan

from ON A BREAK UP

You cannot
remember much
about last night.
He apparently does.
Your words,
your actions,
are used as
a convenient excuse
to break up.
He sits
on the edge
of the bed,
fully clothed,
with his back
to you.
He doesn't
tell you
what happened,
only says
ominously:
what happened, happened.
You still
don't know.
You have analysed
his words
as they matter.
You lie naked
in bed,
in body, in vulnerability.
There is no going back.
His mind is made up.
You ruminate on

what he says
forever and a day
as it matters
to you
what actually happened.
Whatever happened
finished it off.
You were both
teetering
on the edge of
the open-mouthed abyss
for quite
some time.
Whatever you said
or did
simply consolidated it.
You would prefer
if he tells you.
It merely
precipitated
the end, he says.
Ah, so the end is
coming at a point
in time of his
choosing at a place
where he wants
to be in
control
of the shattering of
your fragile heart
without a second thought
for the owner
of such a heart
who will take
years to recover
from such a
brutal bashing.

Nina Mannix

DON'T TALK DOWN TO ME

don't talk down me
about the Black Dog
that sits on my breast
can't you understand or see
how dark how dangerous
He can manifest
stalking, hiding in the shadows
ever watching waiting
to coax me to the gallows
what are the Fates fating
who are you to talk down to me
i cannot control when he steals
inside my soul makes me bow
fight crawl to death beside
it would be better that you could
see the inferno inside of me

Kayleigh Martin

REBUILDING MY GARDEN

The bees dashed throughout the garden
the bright yellow daffodils were their feeding zone.
The butterflies glided graciously around
the daisies, their new home.
With every inhale I could smell the freshly-cut grass.
Neat, clean, calm. There was peace.
One evening the clouds formed
darkness grew within
the air became cold.

The bluebirds flapped their wings
frantically and flew away.
You broke down the gate and stormed in
filled with anger and hate
your arms were swinging
you pulled up my flowers.
You ripped them from their roots.
The leaves turned brown and fell from the trees.
The bees were no longer buzzing.
Their home, my home, no longer safe.
You planted weeds, foxgloxe, poison oak.
Everything harmful grew.

You destroyed what I had built
and you smiled at me because you knew.
The butterflies poisoned. You slaughtered them
like they meant nothing.
Like I meant nothing.
The green grass was now dead.
In its place was brown
dry, crisp. The garden now suffocating in your hate.
Oh how I wish I locked the gate.

Holding a withered leaf in my hand
anger was now planted within me.
The sun peeked through the clouds
kissing my skin where you were once unkind.
I knew it was time. I was no longer small.
I was now a giant gripping onto you.
You were now the one with eyes of fear.
I banished you from my garden.

Rebuilding it with love.
The bees returned; the butterflies revived.
I tore out the foxglove and planted roses.
They had thorns
but don't we all?

There was beauty in my chaos,
there was poison in yours.
You were banished and it took months
of work but I've finally rebuilt my garden.
And this time I've locked the gate.

Orla Martin

FOR A LIVING

I work in a bank.
Herds of morning smokers scurry
as I cross Leeson Bridge by the canal
onto Baggot Street.
A silver door clangs.

Turning on my computer,
numbers boil. Neat rows of blame blink.
The phone rings in accusation.
Five past nine, blood drips
from a paper cut.

Conference call.
Harried demons wail
in stuffy offices.
A potted plant wilts on a desk
in Paris.

Evening tide of suits and traffic.
The lights change as I cross the road.
A duck quacks.
Home, the place in dark,
no milk in the fridge.

Home, at my desk in my room,
blue walls protect me where I can
create
something beautiful,
perhaps.

Mari Maxwell

FLEETING

If the world were full of snapdragons
carmine petals velvet with nectar
would the bumble bee plunge deep?

Would the white mare snore
in the canopy of white thorn?
Or chaffinches swerve along my sightline
to the feeder?

Would barn swallows waltz in Sunday sky
as the hoof falls of the mare shakes
blushing rowan branches?

Here three collared doves
prowl from electricity wires
as the far off pump and thrust
of a swan resonates.

Forget-me-nots at my feet
ox-eyed daisies gaping, stretching
to welcome the day.

The cackle and tat-tatting
of magpies complaining as the tractor
gathers the first cut of the season.

If there were fields of snapsdragons
maybe, just maybe, we'd grasp
how impermanent and precious our world is.

Ger Moane

HINTS TO SELF

Wearing shorts and climbing rocks.
Having a crush on the French teacher.
Longing to be alone with a very good friend.
Fascination with a glamorous aunt.
The deep voice of that radio presenter.

Pissing boys off by ignoring them,
hoping they'd not pay attention.
Even breaking a couple of hearts
when the feelings weren't really the same.

I noticed the lingering silences,
the turning away at anything gay.
The covert glances between two women.
The whisper of 'she never married ...'

Then along came women's liberation
with meetings, rallies and discos
and a house full of women who called themselves lesbian.
I just loved to hang around that house.

And then there was one I really liked.
I loved being around her, she lit my heart.
I wanted her all to myself,
but I wasn't lesbian, not one of them.

I was six thousand miles away
when I finally said 'I am'
in a place of joy, freedom and fun.
There was no stopping me after that.
No stop to falling in love, marching for Pride.
Saying it every time, coming out.

Meg Mulcahy

St Valentine's Visitors' Book

The Whitefriar Street church houses pieces of a
man who may bring us luck.

In the town where you grew up, couples queue.
Boyfriends are dragged to osmosis

blessings from a mosaic heart in a golden
tabernacle. We go for stone-faced fun

the colour of rain throb, Zumba-filled neighbour
pulsing. Service trays of

tea and scones hardwired.

Like statues we stand and skim pleas to break
our own hearts, scoffs dissolved by

scribbles of last resorts and prayers, cures for
what it means to be alive.

In the town where you grew up, the moon has
become a critic. Billboards sing me your

name, asking me to choose; to be loved and
boxed up, or spared

to thumb open wounds.

Sonya Mulligan

You Can't Be

You can't be
You were a beautiful baby
I always made you wear dresses
Oh, I can still see you in that lovely floral print with
the lace trim
your auntie Maisie made you for the bonnie baby
competition
That dress was a work of art
You just can't be

I never let your father play football with you
I was very vigilant about those things
You had every Barbie and Sindy doll on the market –
Oh jesus wept! All those hours you spent dressing
and undressing those dolls
I thought that was normal
Girls are supposed to play with dolls, aren't they?

Oh you were such a beautiful little girl
You were a picture on your communion day
Just like a little bride
Huh I suppose you'll be going to Canada now to marry
some woman with a moustache and covered in tattoos!

How am I going to tell your granny?
It will break her heart
and her so frail lying there in the nursing home
You know she has only been holding out
to see you and your brother settled

Actually mother,
there is something I wanted to tell you about him too ...

Mitzie Murphy

I WILL SIT DOWN AND WRITE WHEN I'VE ...

Polished the moon
Collected the castrated cat from the vet
Cleaned out my brain
Filed my remembered dreams
Called the priest
Fixed the chip on my shoulder
Mopped up the mess from last week
Power-hosed my heart
Juiced all the uneaten fruit
Checked on the baby
Fine-combed the guilt from my hair
Scraped all the dirt from the corners of my family
Kicked myself up the arse
Checked on the baby
Caught my shadow
Sung myself a lullaby
Knitted myself a doll
Checked on the baby
Eaten another Jaffa Cake
Swallowed my screams
Tightened my hold
Washed that look off my face

and
remembered that
the baby in the cot is
gone.

Anne Murray

FOREVER LIMINAL
after 'The Green Coat', *John Lavery, 1926*

Girl from Chicago,
the city of soot
where smog blotted out the sun
and your father mass-machined
pigs into pulp.

There is a grand mantle behind you,
and one small silver foot pokes out
to steady yourself
for hours of pining
in front of the open fire.

There is no peace.

Four years since Béal na Bláth.
The Irish lilt of him
still on your mind.

Little bird, little love.

At forty-six, only bones
buried under the floor-length dress.
Your ring finger unseeable.
Such prettiness could never stay pristine
in a life of smoke and shadow.

His pistol in the folds of your frock.
It was all part of it.

Áine Ní Éalaí

MO BHEALACH ISTEACH

Blaisim salann ar mo theanga nuair a labhrann tú
im cheann a mháistreáis mhín.
D'fháisc do bhealach fileata focail agus deora as cúl
mo chinn.
Phéinteálfainn do sheomra ranga is réiteoinnse
an cócó duitse.
Shocróinn *montbretia* agus deora dé
i vása ar do bhord
agus shuífinn leat ar bhinse
ar thrá an Oileáin
áit a gcasfainn suantraí dhuit
is mé ag léamh do scríbhinní
ar chlár bán na trá.

Úna Ní Cheallaigh

A FAREWELL TO GRIEF AT LAGO MAGGIORE

Like Electra I carry grief on my shoulder,
a weight, always there, unseen,
colouring each day with tinges of grey.
Wanting to heal what I cannot name
I return to these lake waters where Hemingway
rowed nightly to Pescatori, for him
the island that *beat paradise all to hell,*
fishermen guiding his way through darkness.

The swans are here nesting in the shelter of the quay,
their slow glide at sunset, a whiteness more pristine
than the Pallazo reflected in the lake's pink hue.
Sitting by this lake with glass in hand, thoughts slip
and slide, a penny for them? Iced caramels.
I crave sweetness, dolce – *la dolce vita.*

Beirní Ní Chuinn

BRÓGA NA MNÁ SIÚIL

Bean siúil a chnag ar ár ndoras-na lá,
An suipéar díreach ite is boilg bhí lán,
Mise, a cuireadh don ndoras le rá,
Your medals agus sáspain *for them we've NO* gá.

Do bhí cloig ar a cosa ag bróga bhí luí,
Í ag líonadh na bibe agus fonn uirthi suí,
Do dh'fhéach sí ormsa is ina súile bhí an guí,
Go mbeadh againn trócaire ar thuirse mnaoi.

Bhí sí báite fuar fliuch, maraon lena hiníon,
Giobail ag sileadh is a glib ag imeacht le gaoith,
Do ghaibh mo Mháthair an doras gan choinne,
Is do chuir an bheirt suite ar stóil cois na tine.

Do líonadh an mias lán le uisce gan teora,
Tumadh cosa na máthar go hailt ann le scóladh,
Do stánadar beirt is a súile ar leathadh,
Ar Mháistreás an tí, is í ag tindeáil ar dalladh.

Do nigh Mam a cosa le trua is le tuiscint,
Do thriomaigh sí iad is do chuimil dóibh *ointment*,
A thabharfadh di faoiseamh ar phian a bhí doimhin,
Is fuair bróga nua glana di, ná déanfadh í tinn,

Do théigh sí dinnéar don mbeirt a bhí ocrach,
Do chuir orthu casóga, bhí glan, ná raibh gioblach,
Do líon sí lánmhála le arán is le bainne,
Is do cheannaigh sí sáspain, a bhí aici cheana.

Beirt mháthair mhánla ó dhá shaol dhifriúla,
Muirear mór groí acu araon, féna stiúir,

Do thuig saol na broinne, is am seoil lán do phian,
Is a shiúlaigh i mbróga a bhí cúng agus dian.

Do chas an bhean siúil ag gabháil amach di go dtí an
 pábhaile,
'Go méadaí an Tiarna do stór is do shláinte.'
Mo bhuíochas leat Mam, is mórchroíoch tú mar dhuine,
Is Beannaím d'ál mór ó cheann ceann na cruinne.

Ciara Ní É

AN TEANGA MHARBH SEO

Cloisim iad ag maíomh gur teanga mharbh í
is cuma liom sa riach
faic a thuigeann na glagairí
faoi na hamantaí is beo dá mbíonn aici.

Seo í
is mé ag póirseáil trí mo stór focal
ar mo chroídhícheall teacht
ar an gcur síos cuí
don nasc? ceangail? snaidhm? seo eadrainn.

Seo í
is tusa i gcéin ag cogarnaíl orthaí
a eitlíonn ar an aer faoi choim na hoíche
ó do ghléas chuig mo chluas
a bhuí le draíocht.

Seo í
cuireadh
is mé romhat ar mo ghlúnta
in óstán galánta lárchathrach.

Seo í
an teanga mharbh seo
ag doirteadh as do bhéal is tú i mo bhéalsa.

Seo í
an teanga ag lí
an teanga seo a chuimlíonn mo bhrillín.

Seo í, seo í,
seo í arís –

an tuiseal gairmeach.
Gairim ort.
Gairim ort.
Gairim ort.

THIS DEAD TONGUE

I overhear them profess that my tongue is dead
I couldn't care less
they can't even grasp their own lack
entirely blind to her most vital moments.

Here she is
as I root through my vocabulary
wholeheartedly seeking
a fitting definition
for our – bind? knot? tie?

Here she is
far away beneath a starlit sky
as you murmur enchantments into your device
that fly as by magic
through the air to my ear.

Here she is
a suggestion
as I kneel before you
in a trendy city centre hotel.

Here she is
this dead tongue
pouring from your mouth while you are in mine.

Here she is
this tongue that licks
this is the tongue that strokes and flicks.

Here she is, here
and here –
the vocative case.
I call your name.
Your name.
Your name.

Órla Ní Shíthigh

IARSMAOINTÍ TÁBHAIRNÍ

Is ait mar a bhogann
An saol
Sa tslí is
Nach mbogann sé
In aon chor.
Na fadhbanna céanna
Le fearaibh
Ag tabhairt aird
Ar an iomarca
Mnáibh sa phub
Na fearaibh céanna
Ar a gcaid
Beag beann ar obair
An lae amáraigh.
Tá taithí againn air
Mar is dócha
Go bhfuilimid
Chomh hainnis leo
Is sinn ina gcuideachta.

Caitlín Nic Íomhair

TAIBHSE

ná fág ar snámh níos mó mé
ar thonnta tosta

ná luainigh seasta mé
ó philéar go posta

ná hídigh orm feasta
do chiúnas crosta

má tá muid tite go tóin poill
titimis le fórsa
ní mé an lann a leon do lámh
ní mé a mhill do chodladh sámh
más seo é deireadh lenár ndáimh
nár uaisle troid ná scaradh támh?
Thug Darwish ♣ *do do theachtaireacht.*

Margaret Nohilly

IN THE FULLNESS OF TIME

You almost wept to see me framed in
my parents' doorway; wanted to write,
despite agreement: a month exactly with
no contact – your purpose set, mine not.

Now decades on, I'm home from tending
to our grandchildren, catch a flash of that
passion in your look, as we dine together at
the table you had fashioned when overtures

were tentative; the yin/yang band that forged us.
I am suffused with love of you this moment
– not that we've never left the table furious:
this furnace testing and melting us like gold.

Helena Nolan

ON DAG HAMMERSKJOLD PLAZA

I am in Katherine Hepburn's Garden in New York.
A woman gulps at her breakfast and tries to
stop her papers blowing away; a father snatches
the last few minutes with his daughter before
dropping her at day care, and another someone,
shrouded in layers, searches the bins for treasure.
Early this morning I saw a bride walk by, in a white
gown, carrying a small dog and roses in her arms.

There is a place called America which is inside all of us.
And I am here in Katherine Hepburn's Garden now,
because today I realised that for the last three weeks
I have been walking past it, twice each day, sometimes
more, without ever noticing that it was there – here,
where I am – surrounded by concrete and the starless skies.

Maria Noonan-McDermott

WINTER TAPESTRY

When I think of her,
I think of fabric.
Brocade, silk and soft woven wools.
Threads delicately interlaced
with hidden panels and complicated seams.
A cloth of every colour.
Bright and iridescent, shimmering in the light,
each painstakingly designed and constructed.
A winter tapestry,
a patchwork of mixed hues.
A warm blanket that shrouded and protected.
The elusive veil that shaped and formed us,
draped heavily like rich opulent velvet.
When I think of her,
winter turns to spring.
Billowing vintage lace hand stitched.
The intrinsic detail of old linen,
starched, pressed and neatly stored away.
Oh, if only to strip away the fancy layers
and gradually reveal the simple lining underneath.

Sarah O'Connor

EQUILIBRIUM

everything is right
and everything is in the right place
and you are you
and you are right here
and the alarm is set for an hour's time
and there is no expression on your face
and you are breathing deeply

and it is as though i was born this very instant
and everything is brand new
and i am seeing this every whole new thing unroll
and everything is one new thing after another
and you are dreaming
and everything is in the right place

and everything is just right

Grace O'Doherty

VISITORS
for Maureen

I gave the kitchen a good scrub, she says,
for when the visitors come.
The oven door nearly killed me.
But look – how our feet are thrown back to us
by the shine on the glass.
This mat covers the crack in the floor –
this used to be two rooms, do you see,
here was a little room where
my mother liked to stay
so she might make a cup of tea at night
and not wake the house up.

Lani O'Hanlon

THIS IS NOT A WAR POEM

When spring would come around, Cara would join
the others on the hill, all those young men sitting
around the fire, and each year she'd choose one.
'They don't know how to make love,' she told me,
'so I show them.'

I almost wished I was a man to be welcomed on
to the sheepskin rug where she sat like the Goddess,
a red bra strap slipping down her upper arm, vivid.
And the men she chose would go on to live with other
women, generously, gazing at the womb door with awe.

Some judged her but how can anyone know the whys
and wherefores. She never knew her birth mother,
and the biological father, she found out later, had raped
her mother. Conceived in violence, she opened her legs
with love.

Egyptian priestesses practiced their craft in the temples,
threw rose petals in the air to signify the names of lovers
to come. Naming is sacred, earth, woman, mother, child.
You see she was wild like fire or dancing on the hill of
Uisneach. Wild like the ones who cried and screamed
in the old church on the grounds of the asylum.

We used breathwork so our bodies could remember.
Breathe, we said, breathe. Oh Bríd were you there, the
Novus Magnificat coming in above it all? But I don't want to
write about institutions, maiming, domestic violence, war.

I have to tell you about Cara,
the ways she touched those men,
and taught them how to love.

Ruth O'Shea

THRONE

I am climbing up into my grandmother,
into the folds of her cardigan,
into her laughter.

A leana, she says,
a leana.

And I sit with her in the quiet
until her heartbeat matches mine.

Geraldine O'Sullivan

DAUGHTER OF DAGDA

She turns her winter-blackened face to the sunlight
smells the thaw in the air
mountain streams rush rush
carrying news of the daughter of Dagda

fingers unfurl and touch the lip of the lake
her barken body shakes and sheds
layers of wood-soaked fibres

in the water she washes
her long silver arms now silken, now smooth
legs bare and trembling
a bone-white comb unknots her hair

at the lakeshore
ferns reveal a bronze-orange horn
slender, curved, cool
she takes it and raises it to the light
waits

skyward the blackbirds travel
it is time
metal touch of the mouthpiece
now
brushed velvet sounds of snowdrop rise
it is time

Sarah Padden

YAD VASHEM

We spend the day trudging through a raw memorial
cut into a Jerusalem hillside like a Toblerone tube,
we read *Schindler's List*, watch ghettos empty on

propaganda films, see piles of cloth stars, leather
shoes, gold teeth, used canisters, striped clothes,
evidence preserved in colossal concrete halls.

But when I place my fingertips on dirty handprints
left on the aged wood of a rough-hewn bunkbed
that smells of dry, white wine, I touch history

and I'm jolted into a Grimm tale of children
in camps hidden in forests, stinking in freezing
coffin beds stacked with stranger's bodies.

Assistants encased in their own *Gorta Mór*
exude defiance in their red-eye glances
which say Never, Never, Never again.

Rage clings to the sarcophagus justifying new
settlements built on high hilltops, clearances
and reclamation, dams and diverted streams

young fir forests planted for a fresh future
imagined by the first generation, their smiles
displayed in family photos, at the exit.

Saakshi Patel

KALPANA

She laughs, says it's a prime sea-facing home
she built from sheets of corrugated tin,
tottering over craggy rocks and loam.
Government officers often barged in,
threatening demolition till she paid
them off with the promise of her vote.
Wielding a plastic brush and cleaning spray,
she tends to washrooms, earns to stay afloat.
Swirling neon blue liquid anticlockwise
then clockwise, she scrubs loo bowls and drains,
bins the fallen hair, sponges toothpaste stains,
mops sweat with her saree and thanks the skies
for her daughter who finished studying and did well
enough to buy new clothes for mother and self.

Ruth Quinlan

MID-ATLANTIC

The teenager at the front of the bus
sounds like she rose from the surf
mid-way between Boston and Dingle.
A modern Venus born clutching
an iPhone to shield her nipples,
armed with the ideal hashtag
for landing on shore in a scallop shell.

Her vowels are long, her *th*'s clear
in continent-neutral cadences
that ape the influencers
who maximise global appeal
by sounding like nowhere at all.

With this ironing out of inflection,
homogenization of tongues,
her children will speak in Globish:
perfectly pronounced, perfectly generic,
the language equivalent
of the mackerel swarm.

Mary Ringland

BEAT

I have surrendered the urge to save you
but when you text *hi* from number unknown
I reply and think of the fox that stole
into my garden at dawn, hope it survives.

The last time you sent a photograph.
A ripe plum, on kneaded dough, I closed
my eye as if I could share
the load and offered you a home.

The time before you stood the latch chain slated
against your jaw. Held the scruff of a husky
as if it were a fur coat that you could grab as you
walked out the door, someone from the back gaudered,
she's minding the dog.

The first time, for over twenty years, we met in a café,
you ran in straight from work. Your purse bloated
with notes, a Hoover crouched in your car out of sight.
You called me Miss Honey and asked.
did I not know.

The first time I knew you were eight years old,
smarted at noise,
that you stole my fountain pen
but it wasn't your weapon of choice.

I knew I wanted to brush your hair,
rub almond oil into the ends,
that you followed the beat
of a child soldier – another day at war.

Máire Ruiséal

PICTIÚIRÍ ÓN TSEANASHAOL

Ó dhialann mo shin-seanamháthar inniu a d'fhoghlaimíos
go mbíodh daichead imir aoibhinn den nglas,
go mbíodh na haibhneacha lán d'anam is de bheocht,
go mbíodh an spéir ag síorathrú,
go mbíodh crainn le chéile ag fás,
go mbailíodh daoine timpeall ar thine déanach san
oíche ag roinnt.
Nár bhreá lem chroí a bheith beo san am draíochtúil san
go mblaisfinn bia a chuirfinn le mo dhá láimh féin,
go gcífinn bláth álainn leochaileach á shéideadh go
talamh gan bhriseadh,
go mbraithfinn neart an bhric ag léimt as uisce le lón a
dhéanamh as feithid,
go gcloisfinn an bheach ag tabhairt neachtair chun na
banríona go humhal,
go bhfaighinn boladh na hithreach lá samhraidh tar éis
cith báistí trom.
Is dócha gur fúmsa anois atá sé an béaloideas seo a choimeád
beo.

Fiona Sherlock

THE CROWS OF BECTIVE ABBEY

The Abbess looks at me askance
and nibbles the Kit Kat tinfoil.
She has waited eight hundred long years,
turned into a bird.
She watches and she waits.
She admires the tourist crowds, and the change of tempo,
but still misses her body, misses the feel of the wet
cloistered grass under her soft pink human feet.
The abbess is not alone.
There is a murder of crows about this old ruin,
monks and millers, trout anglers and rat catchers,
all gathered here. Beyond the Boyne,
I see Crockett's bar, two hundred and sixty five years ago.
A carriage stops, an over-exposed barouche,
its passengers damp. The first proprietor, I picture,
knew who could repair a carriage wheel.
He prepares a bowl of warm broth for the journeyman
and his lady, sources a doctor, a medicine man.
It's an incurable pre-antibiotic fever that takes her.
This now-feathered lady lurks in the oak tree.

My daughter is two, she runs up and down the ramparts.
She does not know what has been caught in stone.
She examines pebbles in her fat little fingers.
And too tall am I, at five feet two,
for these laneways, openings and stairwells,
unlike the hunched monks carrying crooks and candles,
or water to make up the ink.

The gravel was laid by the Office of Public Works
to prevent lawsuits and muddy boots.
It sieves through those who pass through,

not well-to-do, escape artists, drug addicts,
young drinkers, cans, needles, human waste,
a Calypso wrapper, a crisp packet,
non-descript pieces of plastic,
evidence that will lurk for the next thousand years.

And what does the future hold
if the planet has only ten years left to live?
Is it the winter, the last gasping breath of the Abbey?
These rooks see more than us,
backwards and forwards over aeons of time,
and they know we are on the cusp of destruction.
The Abbess calls to me.
A little hand takes mine.

Amy Smyth

WEDNESDAY'S CHILD

Wednesday's child is full of woe. I made my gentle mother repeat that rhyme to me all the time when I was little – over and over – longing to be 'fair of face' or 'full of grace'. Hell, I would even have taken 'works hard for a living'. As I grew I learned to accept the woe – the bad luck, the doing things the hard way. I grew into my woe – just like the school shoes your mam promises will fit you by September – and they always do. I looked at it differently – it made me revel in the power of difference, stronger – doing things the little girl who longed to be 'fair of face' could only dream of.

Woe became my armour – sometimes too much so. Lessons can still sting at 3am when I struggle to fall asleep. It seeps into who I am – injustice, outrage, all the things that are familiar to Wednesday's child run through my veins like molten magma. I feel it too deeply – my own and others. When woe is your dark friend, you can see it in others who walk alongside her – or carry her heavily on their backs.

First comes realisation, then acceptance. Now, I work on harnessing the woe, channelling her into the very best of things. Making sure, when she rises to the surface to become lava, it is only to make the world a better place – for all of the little girls who long to be 'Fair of Face'.

Just watch us.

Breda Spaight

FISH

She runs the blade
through the gill's silvery flap,
hews the head twice, three times, four;
severs bone, the knife's handle solid
in the oblique arch of her right hand,
her left a wolf's paw holding down fresh catch,
its slipper-like body, mouth open as death
sang its last note of ocean breath. She makes the first cut
to the white belly, a wound like Christ's on the cross,
from where she drags plum, slithering, knotted
entrails; her face childlike; eyes, mouth set as though
freed by the rhythm of ritual, governed by knowledge
leached from her marrow as she steers out the pearly
treasure of the ovaries, roe glistening in her palm.
I am there, a library book on my lap. Each page turned
affirms the story of this woman, my mother, standing
over severed heads with furious eyes; her fingers laced
with luminous scales – for now, a she-warrior,
queen of her domain.

Eilis Stanley

THICKER THAN WATER

Did I tell you I shoplifted in a tartan
poncho, popped eggs into my pockets,
slid tins of duck liver pate in there too
and button mushrooms in olive oil.
Did you know I broke into my old school,
climbed the walls and stole a nun's habit?
Wore it to *West Side Story* in Phibsborough.
The orchestra bass player winked over at me
before the show started. Do you remember
the fag butts we sold, and when Norman
Dexter chased me up our road and pinned
me under him? He was twenty but really seven;
a seraphic look inside a brute bull-strength.
Do you remember picking fraocháns in Wicklow's
hills, our lips purple-stained, jam jars filled
and light dancing on Lough Dan. I remember
Zoo Sundays, elephant rides, bored-numb gorillas
and bald lions. The stare of captivity. And that old
black and white photograph of us, leaning over
an iron gate in the Phoenix Park. I'm a grimace of smiles
with pulled-tight plaits and you're a cloudburst
of unshed tears. I remember a hospital cot and you
with wooden splints round your legs and arms.
You're three, lost in neon lights, loud noises
and strangers. Seeing you slayed me. And the time
you came home from John Fisher with cracked
calves from one of the brothers' beatings and we both
knew there was no God. Did I ever tell you I love
your laugh and the way you jig up and down when
you stand like you're about to fall out of yourself.
You and I, thicker than water poured from one bottle,
vintage fifties with blends of burnt milk and cruelty.

Sarah Strong

ALTERCATION

In Dillons of Dún Laoghaire
photographs are taken:

Daddy drives to Merrion Square,
hands over my application.

'Why the English Embassy?'
Mummy demands:
'Didn't Violet Rooney
deliver her in Donnybrook –
not Holland Park!'

When the hunger strikes began –
I got an Irish passport.

Máirín Stronge

CHILD OF THE SMALL HOURS

grey steel blasts the stillness
of day wearied rest
sleep splinters with memos to self

fear carved memories
distort trust in the day
root deep in long hours of waiting

until skittering clouds
cross streaks of sky
and birdsong reaches, sleep teases
the corners
rounds the edges

flickers quiet

Lila Stuart

END OF THE DANCE

I'm finished waltzing with words,
lost the rhythm – can't find the beat.
Used to be that we would meet
in strange places; mostly in spaces
between thoughts, quiet moments
in the night, out of sight
of the day's turmoil.
They would turn up
dancing through
the slit in
the curtains,
spotlighted
by the safety lamp
on the landing,
winking at me,
cavorting to be sorted
into lines and rhymes –
hints of their immortality.

Couldn't help myself,
felt the pull to move,
bounce, glide and slide
into sequences of stanzas,
nestle in sestets, swerve through verbs,
embrace the shape of sonnets, flirt
with anapests, skirt around dactyls
of spilled vowels and curt consonants.

Strictly speaking, I'm done –
spun out of control,
swayed, strayed and refusing
to be led.

Csilla Toldy

ORLANDO

I was sitting in a pub wearing my favourite dark red
flannel top I had dyed and sewn myself. The softness of it
snugged me into its womb. I was talking about Virginia
Woolf, the letter I wanted to write to her as part of my
project – a depressed teenager, suffering from restrictions.
I may have been on the autistic spectrum. I remember the
tantrums when I was small. My mother soon extinguished
them, pouring a glass of cold water into my face. Still, I
loved the water. It was my essence.

As an adolescent, my method of resistance was to walk
away. My first attempts at criticising a system ended with
fierce suppression. I thought it was brutal, so I ditched
school, on the path of the rebel poet. It was hard to be a
female in the male-dominated world of literature. They
thought you were stupid and tried to keep you on the side,
or seduce you, get into your knickers, everywhere and
every one of them. No wonder you orientated towards
gays, but then they lived in their closed little world, too,
hiding. I had the dream that I shared with many young
girls – of becoming a man – a sex change like in *Orlando*,
but clever Virginia reversed the plot and made Orlando
into a woman. This kept me wondering for years.

I told this to the guy sitting opposite me in the pub and all
he could think of was kissing me, shutting me up.

resist
remember
your essence

Áine Uí Dhubhshláine

MNÁ CAOINTE
do Mazz

(*catharsis*: faoiseamh, saorghlanadh)

Beidh tú ag siúl go mall tríd an
ngeata go Dún Urlann,
radharc na súl imithe uait le
naoi mbliana,
chomh fada le huaigh m'fhir chéile
Mike, agus anois Jeannie.

Stopfar ansan.

Scaoilfidh tú uait do ghlór go
hard is go híseal
i dteanga idirnáisiúnta an cheoil
go dtuigfimid nach bhfuil aon
chuirtín idir sinne is iad.

Morgan L. Ventura

IMAGINING HERITAGE

My friend Ben gives a thumbs up
as his Wrangler Jeep sinks
among palm fronds and azure skies
into Papua New Guinea's quicksand,
a bizarre attempt to capture
the radical realities of 'fieldwork'.

This is true anthropology,
he captions the photograph,
and hundreds across social media
love it, awkward approval
of that colonial ghost that haunts
every ethnography, every seminar

a séance with a pith helmet.
I delete all my photographs,
wincing as my computer crashes.
I wave goodbye to the memory
of that chestnut-haired man in beige,
the curator at Chicago's natural history museum

who beckoned my 4-year-old self and my father
over to Egyptian stelae, slates slatted
against cold concrete walls in the basement.
What do you see? he asked me,
pointing to Demotic script and hieroglyphs,
to which I said with delicious, ironic delight:
Wonderful things.

Milena Williamson

THE ULTIMATE JINX
after *Buffy the Vampire Slayer* episodes *Some Assembly Required,*
When She Was Bad, School Hard and *Teacher's Pet*

I'm bad to the bone or I'm a nice ripe girl.
Have you seen my pruning shears?

Love makes you do the wacky –
an electric current, an adrenaline boost

and a collar with a bell is the ultimate jinx.
I'm nobody's baby; it's neural decay.

I have learned how to deal with my pain.
Give me a tampon, a yo-yo, a stake.

Free therapy for everyone who saw the body!
I would rather eat powdered doughnuts in private.

How are you? PTSD. I mean, peachy!
Am I in danger? Gosh, it's good to be home.

SÍLE AGNEW was born in Dublin, lives in Kildare and loves any time she is lucky enough to spend in Wexford where she wanders, watches and writes poetry, prose and short stories about characters who explore everyday events that conceal the internal conflicts of the heart and soul. She is a watercolourist and a producer.

Limerick-born MARIE BASHFORD-SYNNOTT (MA Women's Studies) is married with four children and lives in Skerries. Currently working on a biography of the Irish writer Annie Smithson for Arlen House, she has won a Society of Irish Playwrights award for a one-act play and is preparing her full-length play, *Ladies Do*, for production. She has published poetry in *The Salmon* and *A New Ulster* and was a prize-winner in the George Moore Short Story Competition. Her trilogy of historical novels was serialized in *Ireland's Own*.

TRISH BENNETT hails from the Leitrim/Fermanagh border. She worked as an engineer for years before she began to write and perform. In 2022, Bennett won the New Roscommon Writing Award. She also received a General Arts Award, funded by the Arts Council of Northern Ireland & the National Lottery, and a Cill Rialaig Residency from the Irish Writers Centre. Her micro-pamphlet, *Borderlines*, is published by Hedgehog Press (2019).

YVONNE BOYLE's poetry and short stories are published in a variety of magazines, books and anthologies including the *Bangor Literary Journal, Dunfanaghy Writers Anthologies* and *Washing Windows Too*. She won the inaugural Sam Overend Award for New Poetry in 2016 after winning the Poetry House Poetry Slam. She was an ACNI Support for the Individual Artist (SIAP) awardee 2018/9. She is a Causeway Coast and Glens Councillor.

CAROLINE BRACKEN's poems have been published or forthcoming in *Poetry Wales, New England Review, Belfield Literary Review*, the *Irish Times, The North, Gutter*, the *Honest Ulsterman, Poetry Jukebox, Best New British & Irish Poets 2019–2021, Washing Windows Too, Skylight 47* and *Howl*. She was granted an Agility Award by the

Arts Council in 2021 and an Emerging Artist Award by DLR Arts Office in 2022. She was selected for the Poetry Ireland Introductions Series 2018.

MARIE BREEN-SMYTH lives in Meenaclady, County Donegal and in County Derry where she was born and has returned after living in Wales, England and the United States. Although her work and publications have largely been social and political research, journalism and some film work, since the 1970s she has published poetry erratically in *The Salmon*, *Poetry Ireland Review*, *Fingerpost*, *Fortnight* and in North American journals. She studied creative writing at Harvard, the Seamus Heaney Centre for Poetry and Grub Street, Boston and was a 1999 recipient of a Cill Rialaig Residency.

CLODAGH BRENNAN HARVEY is a specialist in Irish oral narrative, though poetry is now the focus of her writing. She has published in a number of anthologies and journals, including *Washing Windows* and *Washing Windows Too*. Her poem 'Queue' was shortlisted for the 2015 Bridport Prize, and 'If not *El Niño*, what?' was shortlisted for the Seamus Heaney Award for New Writing (2017).

JACQUIE BURGESS is a medical herbalist and therapist living in County Carlow. She is the author of two published books on crystal healing. Her first poem was published in *Washing Windows Too* in 2022. Jacquie is a great lover of nature – she tends her garden, keeps bees, celebrates the festivals of the Celtic Wheel of the Year and enjoys painting and illustration.

JUNE CALDWELL is a writer from Dublin. Her collection of short stories *Room Little Darker* was published in 2017 by New Island and in 2018 by Head of Zeus. Her novel *Little Town Moone* is forthcoming from John Murray (UK).

LYNN CALDWELL's work has been published in *Poetry Ireland Review*, *Writing Home* and *The Book of Life* (Dedalus), *Cyphers*, *Crannóg*, *Crosswinds Poetry Journal*, *The Irish Times* and *Aesthetica*'s creative writing anthology; and has featured on *Sunday Miscellany*. Now a Dubliner, Lynn is a Canadian calling Ireland her second home.

MARION CLARKE is a short form poet from Warrenpoint, County Down. Featuring regularly in journals and anthologies, her poetry is included in the first two collections of haiku from Ireland. *Financial Times* 'Haiku Poet in the City' winner 2015, Marion combines her visual art and photography with haiku to produce haiga and photo haiku, and she was awarded 'Master of the Month' in NHK World-Japan's programme *Haiku Masters*, 2018. In 2020 she was runner up in the UHTS's *Samurai* Haibun Contest and Grand Prize Winner in the Setouchi-Matsuyama Photo Haiku Competition 2022.

MARTINA DALTON lives in Tramore, County Waterford. Her publication credits include *The Irish Times* and the *Irish Independent's* New Irish Writing, *Poetry Ireland Review, The Stinging Fly, Crannóg, Skylight 47, Channel, The Honest Ulsterman, The Waxed Lemon, The Cormorant, Abridged, The Storms, Rattle, The Stony Thursday Book, Local Wonders,* and *Romance Options* (both Dedalus), and *Washing Windows Too* (Arlen House). In 2021 she was runner-up in the Waterford Poetry Prize and won third prize in the Red Line Festival Poetry Competition. Her poem 'Wedding Dress' won the Listowel Writers' Week Poem of the Year at the An Post Irish Book Awards 2022.

MAUREEN DALY: I came late to poetry. I have been featured in *Revival, Cyphers*, Rush poetry publication (Jane Clarke, editor). Also featured in many anthologies, including *Romantic Options* (Dedalus).

SORCHA DE BRÚN has published poems and short stories in various anthologies, and her work features on the primary curriculum. A recipient of the Foras na Gaeilge Award, the Máirtín Ó Cadhain Short Story Award and Oireachtas na Gaeilge awards, she has translated the work of numerous German poets for the *Dánnerstag* Irish-German poetry project. Sorcha is completing her monograph on masculinities in Irish language writing, forthcoming from Arlen House.

MAIRÉAD DONNELLAN's poetry has been widely published. She has been shortlisted in national poetry competitions including the Cúirt New Writing Prize. Her poetry has been broadcast on RTÉ Radio 1. She was winner of the Francis Ledwidge Poetry

Award in 2013. In 2016 she won the Trocaire/Poetry Ireland poetry competition. In 2018 she was awarded the Tyrone Guthrie bursary by Cavan arts office. She was selected for Poetry Ireland introductions in 2019. In 2021 she was appointed Poet Laureate for Bailieborough as part of the Poetry Ireland, Poetry Town Initiative.

ROSEMARY DONNELLY lives in Ballycastle, County Antrim. She is interested in expressing the essence of human experience through poetry where simplicity can have many layers. She has published in three collections of the Seamus Heaney Award for new writing (Community Arts Project) and the *Something about Home* anthology.

DOREEN DUFFY (MA Creative Writing DCU), studied at NUIM, UCD and Oxford Online. Published in *Washing Windows Too, Poetry Ireland Review, Beyond Words Literary Magazine, The Galway Review, Flash Fiction USA, Live Encounters,* the *Incubator Journal, Ireland's Own Anthology, Woman's Way,* the *Irish Times, The Storms,* among others. Pushcart nominated, she won The Jonathan Swift Award and was presented with The Deirdre Purcell Cup at the Maria Edgeworth Literary Festival. Shortlisted in The RTÉ Short Story Competition, her story 'Tattoo' was broadcast on RTÉ Radio One.

GER DUFFY lives in County Waterford. Her poems have been published by Viking Press, Voxgalvia, The Waxed Lemon, Drawn to the Light Press, *Southword, The Ekphrastic Review, The Bangor Literary Journal, The Stony Thursday Book,* The Milk House, *Local Wonders* (Dedalus Press), *Cathal Bui* anthology, *In the Midst* anthology and *Voices from the Land* anthology. She has won prizes at Westival Poetry Competition, the Goldsmiths' International Poetry Competition, the Red Line Poetry Competition, Fingal Libraries Poetry Competition and the Frances Ledwidge Poetry Awards. She has received mentorships in poetry from the Munster Literature Centre and the National Mentoring Scheme.

MICHELINE EGAN was born in Castlebar, County Mayo. She started her career on provincial newspapers and has worked with words since 1982. She has an MA and an MFA in writing from UCD. She is currently doing a PhD with the University of

Limerick. She was awarded first prize in the Phoenix Literary Festival and was a joint recipient of the Caroline Walsh bursary. Her core themes centre around mothers, mental health, legacies and country & western music grounded in Irish towns.

ORLA EGAN is the author of *Diary of an Activist* (Cork City Library, 2022) and *Queer Republic of Cork* (Onstream, 2016). She is the director of the Cork LGBT documentary, *I'm Here, I'm Home, I'm Happy* (2021) and the forthcoming *Loafers* documentary. Her short play, *Leeside Lezzies* (2018) was performed by LINC Drama in the CAT Club in Cork and at the Outing the Past LGBT History Festival (Cork 2019). Orla is a Queer Archival Activist and Founder and Director of the Cork LGBT Archive.

ATTRACTA FAHY, psychotherapist (MAW NUIG 2017). Winner, Trócaire Poetry Ireland Competition 2021. *Irish Times*, New Irish Writing 2019, Pushcart & Best of Web nominee, shortlisted for Fish International Poetry Competition 2022, OTE 2018 New Writer, Allingham Poetry both 2019 & 2020, Write by the Sea Writing Competition 2021, Dedalus Press Mentoring Programme 2021. Her poems have been published in many magazines and anthologies at home and abroad. Fly on the Wall Poetry published her debut chapbook collection *Dinner in the Fields*, in March 2020. She received an Agility Award from the Arts Council 2022, and is presently working towards a full collection.

EMER FALLON is a poet and fiction writer living in the West Kerry Gaeltacht. Her work has been published in the *Stinging Fly, Banshee, Poetry Ireland Review* and the *Irish Times*, and shortlisted for the Bridport Prize, Fish Poetry Prize and Listowel Poetry Collection Award. Her first collection, *Thin Lines*, will be published by Salmon Poetry in 2023.

HELEN FALLON was born in Monaghan and now lives in Maynooth. She was selected for Poetry Ireland's Introductions series 2022. She has published poems in *A New Ulster, Skylight47, Chasing Shadows, Future Perfect: Fifty Award-Winning Poems* and *Sparks of the Everyday: Poetry Ireland Introductions 2022*. She retired in 2022 from her post as Deputy University Librarian at Maynooth University. Prior to that she worked at Dublin City University and the University of Sierra Leone.

CAROLE FARNAN started writing poetry on her return to her native Belfast in 2012. Since then her work has featured in the *Honest Ulsterman, A New Ulster, Bangor Literary Journal, Corncrake* magazine and on the Poetry Jukebox, as well as in several anthologies. She has won the An Culturlann Poetry Prize (English category) and The Féile an Pobhail short story competition.

TANYA FARRELLY is the author of four books. Her debut short fiction collection *When Black Dogs Sing* (Arlen House, 2016) was longlisted for the Edge Hill Short Story Prize and named winner of the Kate O'Brien Award 2017. Two novels: *The Girl Behind the Lens* (2016) and *When Your Eyes Close* (2018) were published by Harper Collins. She curated and edited *The Music of What Happens*, an anthology of poems, stories and essays published in aid of Purple House Cancer Support Centre (New Island, 2020). Her latest book is the short fiction collection *Nobody Needs to Know* (Arlen House, 2021).

VIVIANA FIORENTINO is originally from Italy and lives in Belfast. Her poems appeared in anthologies (Dedalus Press, Salmon Poetry, Arlen House), magazines (i.e. the *Stinging Fly*) and on air for RTÉ1. They were recorded for the Irish Poetry Reading Archive (UCD). She translated Irish poet Freda Laughton into Italian (Arcipelago Itaca Press, bilingual edition). In Italy, she published a novel and two poetry collections. She is one of the winners of the 2022 Irish Chair of Poetry Student Prize. Viviana is Language Project Artist for Quotidian Word On the Street and is supported by a SIAP grant from ACNI. She is a board member of Irish PEN and Le Ortique, an initiative to rediscover forgotten women artists.

AMY GAFFNEY hails from Kildare and is a graduate of UCD's Creative Writing MA. Her poetry is published in *Poetry Ireland Review*, the *Irish Times* New Irish Writing and in *Washing Windows Too*. Amy's short story *Mother May I* was shortlisted for the Irish Book Awards Short Story of the Year in 2019. Her debut novel *The Moonlight Gardening Club* is published by Avon Books in 2023 under the pseudonym Rosie Hannigan.

SHAUNA GILLIGAN writes fiction, non-fiction and poetry. Her latest book is *Mantles* (Arlen House, 2021), a collaboration with visual artist Margo McNulty, exploring heritage and place symbolising the sacred feminine and Brigid. She has received numerous awards including a Cecil Day Lewis Award (2015), Creative Ireland Award (2022) and a Brigid 1500 Arts and Creativity Grant (2023). She is interested in narrative and history, the perception and interpretation of body, and the crossover of artistic processes.

ANITA GRACEY has been published in *Poetry Ireland Review, Washing Windows, Washing Windows Too, Abridged, Honest Ulsterman, Poetry NI, Poets' Republic, Fly on the Wall, Blue Nib, Culture Matters, CAP, Bangor Literary Review, Corsham, Sonder, Utopia Project, Dream Well Writing, Corncrake Magazine* and Poetry Jukebox.

ANGELA GRAHAM is from Belfast and lives in Northern Ireland and Wales. *Sanctuary: There Must Be Somewhere* was published by Seren Books in 2022. Her short story collection, *A City Burning*, came out in 2020 and was longlisted for the Edge Hill Short Story Prize. She is an award-winning tv and film producer.

MIM GREENE is a transpersonal therapist and poet from Drogheda. She is the daughter of the Patrick Kavanagh Award winner Angela Greene. She has contributed to Sublimer wishes on Lyric FM and was interviewed for American radio discussing the spiritual elements of her own poetry. She was included in *Washing Windows Too*. She happily resides in Portobello with her kitty muse Kismet!

ANITA GREG was born in London and came to Belfast to run a shop in the North St Arcade selling pagan oddments and never looked back. She likes walking in bad weather, mythology, painting and bees. Published in the *Honest Ulsterman, Abridged, Forxfour* and the Waterways Festival booklet, she has also written a play about Emily Brontë, Emily Dickinson and a murder in a carriage which, strangely, has never been produced.

SINÉAD GRIFFIN has been published in *Poetry Ireland Review*, the *Honest Ulsterman, Skylight 47, Channel Literary Magazine*, the *Irish*

Times New Irish Writing, the *Waxed Lemon*, the *Milk House*, the *Storms* journal and elsewhere. Winner of the Trócaire Poetry Ireland Competition 2021 (adult unpublished category), Pushcart nominated 2022, two chapbooks highly commended in the Fool for Poetry Prize 2022, shortlisted in the Fish Poetry Prize and South Dublin Libraries Poetry Prize, longlisted for Cúirt Poetry Prize and Bray Literary Festival Poetry Prize. Her poems have appeared in various anthologies.

SHARON GUARD is a student on the MA Creative Writing Programme in the University of Limerick. She writes mostly short stories and is working on a novel. She was the winner of the Molly Keane Creative Writing Award 2020 and has had stories and poetry listed in other competitions. Her short story 'Communion' was published in New Irish Writing in the *Irish Independent* in January 2023.

CHRISTINE HAMMOND began writing poetry whilst studying English at Queen's University Belfast. Her early poems were published in *The Gown* and *Women's News* where, as one of the original members, she also wrote arts reviews and was published in *Spare Rib*. Her poetry has been featured in anthologies including *The Poet's Place* and *Movement* (Community Arts Partnership), *The Female Line* (NI Women's Rights Movement), *The Sea* (Rebel Poetry Ireland), *Washing Windows, Washing Windows Too* and *Her Other Language* (Arlen House). She is currently working on her first collection.

RACHEL HANDLEY is a poet, science fiction author and an academic philosopher based in Dublin. Their poetry has been published by *Poetry Ireland Review,* the *Liminal Review,* Arlen House, and *The Storms,* among others. She was nominated for the Pushcart Prize, longlisted for the BSFA Best Short Fiction Prize, and shortlisted for the South Dublin Libraries Poetry Competition. Their debut short story collection, *Possible Worlds and Other Stories,* was published by Ellipsis Imprints in 2022.

PHYL HERBERT was born in Dublin and worked for many years as an English and drama teacher in prison schools and in Liberties College. In 2008 she achieved an M.Phil in Creative Writing from TCD. It was only then that she started to write. She has since

published a debut collection of short stories, *The Price of Desire* (Arlen House, 2016) and an essay in *Look! It's a Woman Writer!* (Arlen House, 2021). Her memoir, *The Price of Silence*, will be published in 2023.

FLORENCE HEYHOE is a poet and textile artist living in County Down, by the shore of Carlingford Lough. She has been writing poetry for a decade but for the last four years the haibun form is her focus. Her work has been anthologised and published in journals in Ireland, the UK, India, America and Canada. With a keen eye for detail her inspiration comes from the landscape, family, friends and observing life. She is active on the blog Triveni Haiku India, where she has honed her skills under the guidance of the editorial team.

JENNIFER HORGAN is a poet living in Cork. Her work has been published in various online and print journals including *The Honest Ulsterman, Ink Sweat and Tears* and *Howl: New Irish Writing*. Her debut poetry collection is due in 2025.

DEIRDRE HYLAND is a retired teacher/researcher from Belfast. Her interest, throughout her career, has been in the emotional well being of children. She studied at the Tavistock Clinic in London and has undertaken research work in early years provision at the University of Roehampton. Recently she has combined her interest in art and literature through writing ekphrastic poetry.

JEAN JAMES was born in Northern Ireland, but lives in Swansea. She completed a Creative Writing MA at Swansea University with a focus on nature writing and poetry. Jean has published in *Abridged* and the *Welsh Arts Review*. She won The British Haiku Society haibun competition in 2013; came first and runner-up in the British Haiku Society tanka competition in 2015; and third in the Welsh Poetry Competition in 2018. A selection of her poems was published by Snapshot Press in 2019. In 2021 Hedgehog Press published *Bloom and Bones*, a collaboration with Welsh poet Rae Howells.

ROSEMARY JENKINSON is a playwright, poet and fiction writer from Belfast. In 2018 she received a Major Artist Award from ACNI. She was artist-in-residence at the Lyric Belfast 2017 and

the Leuven Centre for Irish Studies 2019. Arlen House publish her plays *Billy Boy* and *Silent Trade*. Her short story collections are *Contemporary Problems Nos. 53 & 54*, *Aphrodite's Kiss*, *Catholic Boy* (shortlisted for the EU Prize for Literature), *Lifestyle Choice 10mgs* (shortlisted for the Edge Hill Short Story Prize) and *Marching Season*. Her latest collection is *Love in the Time of Chaos* (Arlen House, 2023).

ANNE MARIE KENNEDY is an award-winning writer, poet, playwright, freelance journalist and creative writing tutor. She lives in rural Galway with her husband and a menagerie of four legged people. Her spoken word CD 'Is that a Galway accent' is available.

WILMA KENNY graduated from QUB in 1978 with a degree in English and Psychology. In 2014 she was joint runner up in the Trocaire Poetry Ireland competition and came 2nd in Carers UK creative writing competition (poetry section). In 2016 she had a short story published in the *London Journal of Fiction*. In 2018 she was published in *Open Ear* and had a short story in *Answer the Call* (Whiskey and Words). She was the winner of the Waterford Writers Poetry Competition 2018. In 2019 she won the Dalkey Creates Poetry Competition.

ELAINE KIELY is a poet and writer from Cork. She holds a degree in English and is a student of the MA in Creative Writing at the University of Limerick. In her poetry she likes to explore womanhood, motherhood, generational bonds and trauma.

THERESE KIERAN lives in Belfast. Her work has appeared in many magazines and anthologies including the *Honest Ulsterman*, *Apiary*, *FourXFour*, *Washing Windows*, *Coast to Coast to Coast*, *CAP*, *26 Armistice 100 Days* and Poetry Jukebox. She is a board member of Irish PEN and a professional member of the Irish Writers Centre and 26 Characters. In February 2023 her poems were published by Paekakariki Press in *Dark Angels: Three Contemporary Poets Book One*. In 2015 she was runner-up in the Poetry Ireland/Trocaire competition. She has received two ACNI SIAP awards.

SUSAN KNIGHT is author of six novels and three short story collections, including *Out of Order* (Arlen House, 2015). Recent books include her *Mrs Hudson Investigates* series of mysteries, involving Sherlock Holmes's landlady. Great fun to write. She lives in Dublin.

RÓISÍN LEGGETT BOHAN was chosen by Poetry Ireland for Introductions 2022. Her work appears in 'New Irish Writing', *Southword*, Poetry Ireland's ePub anthology among others. Her poems have been highly commended/shortlisted for the Allingham, Cúirt and Hammond House Award. In 2022 she was the Flash Fiction winner with *Southword*, the winner of CNF with Atlantic Currents II, and runner-up in the Martín Crawford Short Story Award and From the Well Short Story Award. The recipient of an Arts Council Agility Award, and Cork City Bursary, Róisín is also co-editor of *HOWL New Irish Writing*.

JACKIE LYNAM is from Dublin. Her poems have been published in *Washing Windows Too: Irish Women Write Poetry*, *The Covid Verses* (Paddler Press), the *Martello Journal*, the *Bangor Literary Journal*, *Honest Ulsterman* and *Boyne Berries*. She was shortlisted for the 2021 Anthony Cronin International Poetry Award, the 2018 Bangor Poetry Competition and Write by the Sea Competition. She has also written non-fiction pieces for the *Irish Independent* and RTÉ Radio One's Sunday Miscellany.

A native of Strokestown and living in Portumna, NOELLE LYNSKEY, poet and pharmacist, just completed her MA (Creative Writing) in UL. Selected as Strokestown's Poet in 2021 and working on her poetry collection, she also facilitates Portumna Pen Pushers and is artistic adviser to Shorelines Arts Festival. Readings include Cúirt, Clifden Arts Festival, RTÉ Sunday Miscellany, Dromineer Literary Festival, Lime Square Poets. Publications include *Staying Human*, the *Irish Times*, *Washing Windows Too*, *Local Wonders*, *Crannóg*, *Boyne Berries*, *Drawn to the Light*, *Romance Options* and *Skylight*.

COLETTE MCANDREW: I was born in Oxfordshire and have lived in Antrim and Dublin. My interests are in the similarities and differences between places. My poems have been published in *Boyne Berries*, *A New Ulster* and by Arlen House. I have

broadcast pieces for Lyric FM, included in their anthology *Ten Years of the Best of Irish Writing*.

CATHERINE MCCABE is supported by ACNI and The University of Atypical. Her work appears in *Her Other Language* (Arlen House, 2020) and *Washing Windows Too*. In 2022 she was shortlisted for Black Spring Press Group's Best of the Bottom Drawer Writing Prize for *Stiletto Heels & Moonshine*, her comic novel manuscript. She won Button Poetry's Short Form Poetry Contest in 2020 and was shortlisted for the Fly on the Wall Press Aryamati Poetry Prize 2020. In 2016, she co-authored a memoir for an ex-CIA informant, *The Black Market Concierge*.

FELICIA MCCARTHY is a poet, editor and creative writing facilitator in Fingal, County Dublin. Her poetry is online at the POETHEAD.com Archive of Irish Women Writers and in other online zines and in print in Ireland, USA and the UK. Salmon Poetry contracted to publish her first collection in 2023.

MARY MCCARTHY holds an MA in Creative Writing from the University of Limerick where she graduated with First Class Honours. She was shortlisted for the Patrick Kavanagh Award in 2022. Her poetry has appeared in *Crossways Literary Magazine, Riverbed Review, Spirituality,* the *Southern Star,* the *Echo* and in the anthologies *Washing Windows Too, Chasing Shadows* and *A World Transformed.* She has completed two poetry collections and is working on her third.

DEIRDRE MCCLAY has published poetry and short fiction, including work in *Crannóg,* the *Irish Times, Boyne Berries,* the *Honest Ulsterman* and *Wordlegs.* She has been nominated for a Hennessy First Fiction Award and is a member of the Garden Room Writers in Donegal.

HELEN MCCLEMENTS is a teacher, writer and blogger from Belfast. A regular at the Belfast storytelling event 'Tenx9', she appears frequently on their podcast, and several of her stories have been aired on BBC Radio Ulster's programme 'Tell Tales'. An excerpt from her upcoming memoir appeared in *Fortnight* in April 2022, and one of her poems featured in *Washing Windows Too*.

Dr HANNAGH MCGINLEY is a member of the Irish Mincéir/Pavee (commonly referred to as Travellers) community. Her research expertise is Traveller education, anti-racism, culturally responsive and intercultural approaches to education. Her roles have included post-primary school teacher, community development practitioner, casual lecturer and module coordinator. She is currently conducting research on the experiences of Irish Travellers in further and higher education.

ELLIE ROSE MCKEE is a writer and visual artist from Belfast. Outside of Arlen House, she has had poems published by Nine Muses Poetry, and Black Bough; has had short stories included in Women Aloud NI's *North Star* anthology, *The Bramley* and *Scarlet Leaf Review*; and has been blogging for over ten years.

A first-generation Caribbean migrant, RAQUEL MCKEE applies a range of poetic styles to address personal and political issues to a number of audiences. She is a multi-disciplinary, multi-award-winning artist, who has poems published in collections in Ireland, the UK and in Jamaica, namely: *Four x Four Poetry Journal. The Corridor* xBorder edition; *Writing Home; Her Other Language; Fortnight; Lockdown Rhythms* & *JCDC* anthology 2022. She has performed at various festivals including the Cúirt International Festival of Literature. Raquel is a Poetry in Motion facilitator.

E.V. MCLOUGHLIN's writing has appeared in the *Blue Nib, Awkward Mermaid, Bangor Literary Journal, The Writer's Cafe, Rat's Ass Review, Honest Ulsterman, Wizards in Space* and several CAP anthologies. Her poems were longlisted for the Seamus Heaney Award for New Writing 2016 and shortlisted for the Fresher Writing Prize 2017. She loves walking by the sea, coffee, books, and city lights; and currently lives in County Antrim with her husband and son.

TRIONA MCMORROW lives in Dún Laoghaire. Shortlisted in the International Francis Ledwidge Poetry Competition 2009/ 2011/2013; the Galway University Hospital's Arts Trust poetry competition 2013 and the Rush poetry competition 2017. She has a poem published in *The Peoples' Acorn*, in the grounds of Áras an Uachtarain, commissioned by President Michael D. Higgins and

Sabina Higgins in 2017. She has been published in *Cyphers, North West Words, Ibbetson Street* (Boston), *Bealtaine* and *Washing Windows Too*. Triona had a poem published in an exhibition curated by ArtnetDlr. She is a member of the Green Kites writing group.

WINIFRED MC NULTY has won the iYeats, Boyle and Westport Poetry awards and has published poems in *Poetry Ireland Review, The North, Cyphers, Mslexia, Southword* and in *Local Wonders* and the *Red Line Anthology*. She has read her work on RTÉ's Sunday Miscellany.

JOSEPHA MADIGAN is a solicitor, author and public representative.

My name is NINA MANNIX and I live in County Clare. I studied journalism and did an internship at a newspaper where some of my articles were published. This poem for *Washing Windows III* will be my first published poem. I'm currently doing a Masters in Creative Writing at the University of Limerick.

KAYLEIGH MARTIN is a 24 year old writer from Tipperary town. She is currently doing a masters in creative writing in UL and working on both a novel and a poetry book which she hopes will be ready for publication by the end of the year. Kayleigh has been passionate about writing all her life and dreams of putting herself out there as an author.

ORLA MARTIN has had poetry published in *Washing Windows Too, Poetry Ireland Review,* the *Cúirt Journal, Crannóg* and the *Stony Thursday Book* and work broadcast by RTÉ and Dublin City FM. Her poetry has been shortlisted for many awards including the Hanna Greally Literary Awards, the Jonathan Swift Creative Writing Award, Gregory O'Donoghue International Poetry Prize and the Francis Ledwidge Poetry Award. Orla works as the administrator at the Irish Writers Centre in Dublin.

MARI MAXWELL's work featured in *Washing Windows Too* and in the Poetry Jukebox STARS curation. She received a professional development award from the Arts Council and a Words Ireland/Mayo County Council mentorship. Her work has been shortlisted in: From The Well, Cork County Council,

2020/2017/2015; creativewritingink.co.uk 2019; Walking on Thin Ice: Writers Fighting Back Against Stigma and Institutional Power 2014. Third in the Cathal Buí Blacklion Poetry Competition 2019; Second place poetry Dromineer Literary Festival 2015, second place short story 2008. She was longlisted for the *RTÉ Guide* Penguin Short Story 2015 and Highly Commended in the Francis Ledwidge International Poetry Festival 2018/2014.

GER MOANE is a writer, psychologist and shamanic practitioner. She is author of *Gender and Colonialism: A Psychological Analysis of Oppression and Liberation*. Her forthcoming novel, *Winter Sun*, set at the time of Newgrange, imagines an ancient Ireland where people live in harmony with earth and sky, and gender and sexuality are fluid. She is Associate Professor Emeritus at UCD, and produced the award-winning documentary *Outitude, the Irish Lesbian Community*.

MEG MULCAHY received a place in Poetry Ireland's Introductions series in 2022, and is a prize-winning flash fictionist. Her work appears in *HOWL New Irish Writing, An Capall Dorcha* and the Pendemic project for the Irish Poetry Reading Archive at UCD. She has read at Lime Square Poets, the Abbey Theatre and the streets of Dublin for the centenary of Ulysses, Bloomsday 2022.

SONYA MULLIGAN is a director, producer, poet, painter and crafter. She is the host of Pride Poets, a monthly poetry night. *Outitude: the Irish Lesbian Community* which she directed is her first feature documentary and won a number of audience awards and a Community Visibility Award.

MITZIE MURPHY has a BSc in Psychotherapy, Dip in Expressive Arts Therapy and an MA in Creative Writing. Her poetry has been published in *Washing Windows Too* and by Poetry Day Ireland. One of her short stories was published in the *Irish Times*. Mitzie's poetry was shortlisted for Cracked Anvil and longlisted for Bridport.

ANNE MURRAY is a keen family historian and enjoys writing creative memoir. She is currently taking a class at QUB exploring the use of ekphrasis to write poetry and prose, particularly in

response to art treasures housed in the Ulster Museum. Anne has been published in Women Aloud NI's book of short stories and poems, *North Star.*

ÚNA NÍ CHEALLAIGH was born in Dublin. She holds an M.Phil in Theatre Studies from Glasgow University and a Masters in Creative Writing from UCC. Her poetry has been widely published in the *Irish Times, Poetry Ireland Review,* the *Stony Thursday Book, The Quarry Man, Crannóg, The North, Poetry Salzburg Review* and *Washing Windows.* She was shortlisted in Poems for Patience 2019. Her poetry collection, *The Colour of Time* (Arlen House, 2023), is launched at Strokestown International Poetry Festival.

BEIRNÍ NÍ CHUINN: Ó Chorraghráig i bParóiste Mórdhach í Beirní. Duine de dheichniúr muirir í le Muiris Ó Cuinn agus Peig Sheáin Jimín, ná maireann. Tá sí i mbun iriseoireacht na Gaelainne le cúig mbliana fichead. Níl sí i bhfad ag cumadh filíochta agus n'fheadar sí ó thalamh an domhain cad as a tháinig na dánta!

CIARA NÍ É, bilingual poet, performer, playwright and screenwriter. The founder of REIC, a monthly multilingual spoken word event and co-founder of LGBTQ+ arts collective *AerachAiteachGaelach.* Chosen as one of the *Irish Examiner*'s '100 Women Changing Ireland in 2022' and an Irish Writers Centre ambassador. 2023 Artist in Residence with UCD Scoil ICSF, previously with the Dublin Fringe Festival and DCU. Has performed in New York, London, Brussels, Sweden and across Ireland. Published in anthologies *Bone and Marrow/Cnámh agus Smior, Queering the Green, Washing Windows Too, Aneas, Icarus,* and *Comhar.* Her first collection is forthcoming.

Is as Cois Fharraige í ÁINE NÍ ÉALAÍ agus cónaí anois uirthi i gCorca Dhuibhne. Is maith le Áine a bheith ag scríobh dánta, drámaí agus liostaí siopadóireachta. Tá duaiseanna bainte amach ag Áine ón Oireachtas, ó Choláiste na hOllscoile, Corcaigh agus ón gComhlachas Náisiúnta Drámaíochta.

Is file agus gearrscéalaí í CAITLÍN NIC ÍOMHAIR as Contae an Dúin. Tá sí ina léachtóir le litríocht na Gaeilge in Ollscoil Mhá Nuad ó bhí 2019 ann. Caitlín Nic Íomhair is a poet and short

story writer from County Down. She has been lecturing in Irish language literature in Maynooth University since 2019.

Is ó Bhaile Eaglaise i gCorca Dhuibhne í ÓRLA NÍ SHÍTHIGH. Céim san Eolaíocht agus sa Ghnó atá aici ach tá sí fillte ar a fód dúchais anois le dhá bhliain agus í ag obair in earnáil na Gaelainne. Seo an chéad uair a foilsíodh dánta dá cuid.

MARGARET NOHILLY, Lanesboro, County Longford, formerly of Kilbeggan, County Westmeath, was awarded the inaugural Padraic Colum Poetry Prize (2018) and the Goldsmith Literary Festival Poetry Prize (2019). Lapwing published a chapbook of her early poems, *April Promise*, in 2009, and her work is widely published. Her debut is *The Overlap of Things* (Arlen House, 2023).

HELENA NOLAN is a Patrick Kavanagh Award winner and was shortlisted for the Hennessy, Strokestown and Fish awards. She holds an MA in Creative Writing from UCD and is widely published in anthologies and journals, including in *Washing Windows Too* and *Poetry Ireland Review*. As Consul General of Ireland in New York, she has a focus on cultural diplomacy and loves to support Irish writers and artists, especially less-known voices. Helena is co-editor of *All Strangers Here* (Arlen House).

Originally from Donegal, Irish artist and poet MARIA NOONAN-MCDERMOTT now lives and works from her studio in Kinlough, County Leitrim. Heavily influenced by the impressionist movement, her work focuses on the study of light and form in Irish landscapes. She qualified and worked in the fashion industry before returning to study Fine Art at the University of Ulster. To date, she has participated in 24 solo exhibitions and numerous group exhibitions, both nationally and internationally.

SARAH O'CONNOR studied in UCC and in Boston College. Her poetry has been published in *Washing Women Too*, the *Irish Times* 'New Irish Writing', *The North, Wordlegs, Skylight 47, The Weary Blues* and *Poethead*. She is working on a first collection and a young adult novel.

GRACE O'DOHERTY is from Wicklow and is currently based in Berlin. Her poetry has been published in *Washing Windows Too:*

Irish Women Write Poetry, Poetry Bus, Poetry Ireland Review, Banshee, Honest Ulsterman, Stony Thursday Book and *My Kinsale: An Anthology.* In 2022 she attended the Poetry Summer School at the Seamus Heaney Centre and participated in the Gallery autumn workshop series. She was one of ten poets selected for a masterclass and reading with Paul Muldoon at Kinsale Arts Weekend 2022.

LANI O' HANLON won the Poetry Ireland/Trocaire Competition, 2022 and is a Poetry Ireland's introductory poet. She received a project award from the Arts Council in 2023. Her collection will be published by Dedalus in 2023/2024. She is a regular contributor to *Sunday Miscellany.* Her poetry is widely published.

RUTH O'SHEA is an Irish writer based in Limerick. Her short memoir collection was published in the Fish Anthology 2018 and her poetry was published in *Washing Windows Too.* She received a scholarship and bursaries from the Vermont College of Fine Art, The Word Factory London and Murphy Stockton Writing of Stockton University. In 2021 she won the Over the Edge Flash Fiction Slam and third prize in the Frances Browne Poetry competition. In 2023 she was awarded first class honours for an MA in Creative Writing at the University of Limerick.

GERALDINE O'SULLIVAN is a winner of the Originals Short Story competition at Listowel Writers' Week and was placed second in the J.G. Farrell Award at the West Cork Literary Festival. Her sketch, *Two Shapes Walk into a Bar,* ran for three nights at the University of Limerick. She wrote the radio documentary *Irish Coffee Undressed,* and her audio content has aired on West Limerick 102FM and Radio Kerry. She is currently undertaking an MA in Creative Writing at UL and working on her debut novel.

SARAH PADDEN is an Irish-descent Yorkshire lass who lives in Galway. Her poetry reflects on the migrant experience, landscapes and being at home or being Other, in different cultures and countries. Sarah's poetry has previously been published in the *Washing Windows* anthologies, *Skylight 47, ROPES, A New Ulster, Freehand.* She was selected as a featured reader at Over the Edge 2019 and the 2020 Cuirt Literary Festival

New Writers showcase. Sarah was a former winner of the Galway Poetry slam and was shortlisted for the 2023 Saolta Arts Poems for Patience competition.

Saakshi Patel earned an MA in Poetry with distinction from QUB. She was awarded the Seamus Heaney Centre International Scholarship, the 2021 Ireland Chair of Poetry Student Award and the John Hewitt International Summer School Bursary. Her poems have been published in *The Best Asian Poetry 2021* by Kitaab, *Local Wonders* (Dedalus), *Washing Windows Too, AHVAAZ* by the League of Canadian Poets, *Catatonic Daughters*, the *Honest Ulsterman* and *yolk* literary journal. She was featured in Breaking Ground Ireland 2022, a Cúirt International Festival of Literature project.

Ruth Quinlan is originally from Kerry but now lives in Galway. She has been selected for a Heinrich Böll Cottage Writer Residency, the Cork Poetry Festival Introductions, and the Poetry Ireland Introductions series. She has won awards for both poetry and fiction and is co-editor of *Skylight 47*.

Mary Ringland lives in County Down and works as a teacher. She has been longlisted and shortlisted for the Annual Bangor Poetry Competition 2020. Her work has appeared in *Washing Windows, Her Other Language, Washing Windows Too* (Arlen House, 2017/2020/2022); the *Bangor Literary Journal*, CAP anthologies and *Romance Options* (Dedalus, 2022).

Máire Ruiséal, Corcaíoch ag maireachtaint i gCorca Dhuibhne. Chaith sí gach samhradh dá saol ag rith trí ghoirt Bhaile an Eanaigh, áit inar rugadh agus tógadh a máthair. Tá beirt clainne aici agus is múinteoir teangacha agus drámaíochta í i bPobalscoil Chorca Dhuibhne sa Daingean. Tá sí fós ag rith trí ghoirt!

Fiona Sherlock is a 33-year-old writer from Bective, County Meath. In 2023 Hodder Fiction/Hachette publish *Supper for Six,* her third mystery novel. A weekly columnist for the *Sunday Independent*, the Irish Writers Centre selected her for the Evolution 2022 programme, and she was the 2021 Meath Writer in Residence. She is completing an MSt in Creative Writing at Cambridge University, working on an immersive biography of

Mary Lavin. Before taking her writing fulltime in 2019, she spent a decade working in corporate public relations. Her poetry has been published in the *Sunday Independent* and anthologised.

AMY SMYTH is from Dundalk. The signing of the Good Friday Agreement when she was 8 had a profound effect on how she viewed peace and the power of forgiveness. Amy is a diplomat who lives in Belfast with her finance Kevin and dog Friday – named after the Good Friday Agreement. Amy is also dyslexic and is a passionate advocate for people with disabilities and the LGBTQ community in her free time.

BREDA SPAIGHT's work has appeared in *Poetry Ireland Review, Southword, Cyphers,* the *Stinging Fly, Banshee, Ambit, Aesthetica,* and is forthcoming in 'New Irish Writing'. She won the Doolin Poetry Prize, the Boyle Arts Festival Poetry Prize and was 3rd place winner in the Allingham Poetry Prize. She was shortlisted for the Cúirt New Writing Prize, the Red Line Poetry Prize and the iYeats International Poetry Prize. Her debut collection is *Watching for the Hawk* (Arlen House, 2023).

EILIS STANLEY lives in Ashford, County Wicklow. She has won a number of poetry awards including Bridport, Listowel First Prize Single Poem, Listowel International Poetry Collection Prize, and has been shortlisted for the Fish, Strokestown and Hennessy awards. Her poems have been published in anthologies and magazines including Bridport, Listowel, *Poetry Ireland Review* and *Washing Window Too.* She has recently completed her first poetry collection.

SARAH STRONG is a visual artist and poet, born in 1949 in Dublin to an Irish Catholic mother and English Protestant father. Her poems appear in *Southword, London Grip, Silver Stream, Washing Windows, Washing Windows Too, Prodding the Pelt, South Bank Poetry.* She was shortlisted for Fire River poetry competition (2016). She has read at City Lit. Talks Back, Camden Poets. Her exhibition *Washing Soot off Stained Glass: Poetry and Art with Eithne Strong and Sarah Strong* will be held in autumn 2023 at Maynooth University in tandem with MoLI.

MÁIRÍN STRONGE is a MA in Creative Writing student at the University of Limerick having previously attained a First in Creative Writing for Publication at Maynooth University. Her short fiction has been longlisted by Fish, shortlisted by New Irish Writing, placed second in Dalkey Creates Festival, highly commended and published in *Ogham Stone* 2022. A further short story will appear in *Ogham Stone* 2023. From Mayo, she lives and writes in Westmeath.

LILA STUART lives in Belfast. Her poems have been published in *Washing Windows, Burren Insight, CAP anthologies, Her Other Language, Corncrake.*

CSILLA TOLDY is a writer and translator from Hungary. Her writing appears in magazines and anthologies and in three poetry pamphlets: *Red Roots – Orange Sky* (2013), *The Emigrant Woman's Tale* (2015) and *Vertical Montage* (2018), as short fiction in *Angel Fur and other stories* (2019) and as a novel, *Bed Table Door* (2023). Csilla creates film poems as a visual artist. Her award-winning work has been screened at international festivals. Her first full collection of poetry is forthcoming with Salmon in 2023

ÁINE UÍ DHUBHSHLÁINE: Tá cuid mhaith dá saol caite ag Áine ar an nGráig in Iarthar Dhuibhneach. Cumarsáid tré phictiúirí agus focail i dteannta a chéile chun scéal a insint is fearr léithe. Bíonn leathshúil aici ar an dtimpeallacht i gcónaí. Taitníonn 'a scéal féin' agus scéalta a muintire ana-mhór léithe agus is breá léithe leanúint ar aghaidh sa seánra san. Tá an chuid is fearr don tsaol le teacht fós a deir sí!

MORGAN L. VENTURA is a writer and curator based in Belfast whose poetry appears in *Banshee, Romance Options* (Dedalus), the *Honest Ulsterman* and *Shoreline of Infinity*, whilst prose appears in *Best Canadian Essays 2021, The Magazine of Fantasy and Science Fiction* and *Lackington's*. Morgan holds a PhD in Anthropology from the University of Chicago and a MA in Poetry from the Seamus Heaney Centre.

MILENA WILLIAMSON recently completed her PhD in poetry and is currently the Ciaran Carson Writing and the City Fellow at the Seamus Heaney Centre, QUB. She has received the Eric Gregory

Award and the Ireland Chair of Poetry project award. Her debut pamphlet, *Charm for Catching a Train*, was published by Green Bottle Press in 2022. Her debut collection is forthcoming in 2023.

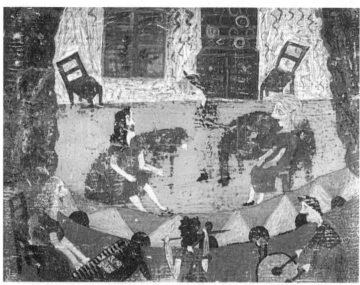

Pauline attended Anew McMaster's Shakespearean plays at the Carnegie, Kenmare, c. 1940. She painted this scene on a wooden board.

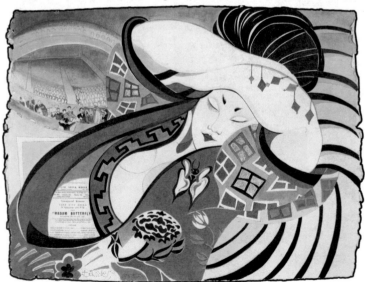

MADAM BUTTERFLY
watercolour • 24" x 32" • 1983

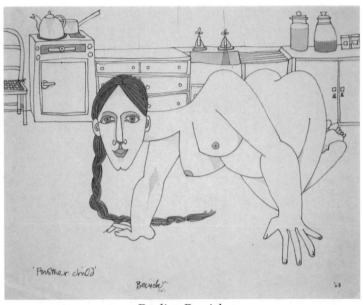

Pauline Bewick
ANOTHER CHILD
ink • 11" x 14" • 1963

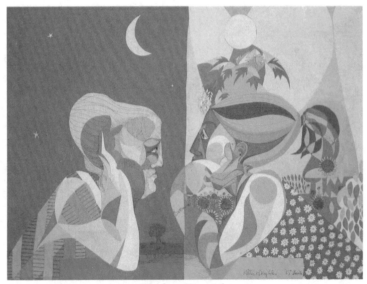

Pauline Bewick
MOTHER AND DAUGHTER
poster colour • 22" x 30" • 1967